SHADES OF LOVE

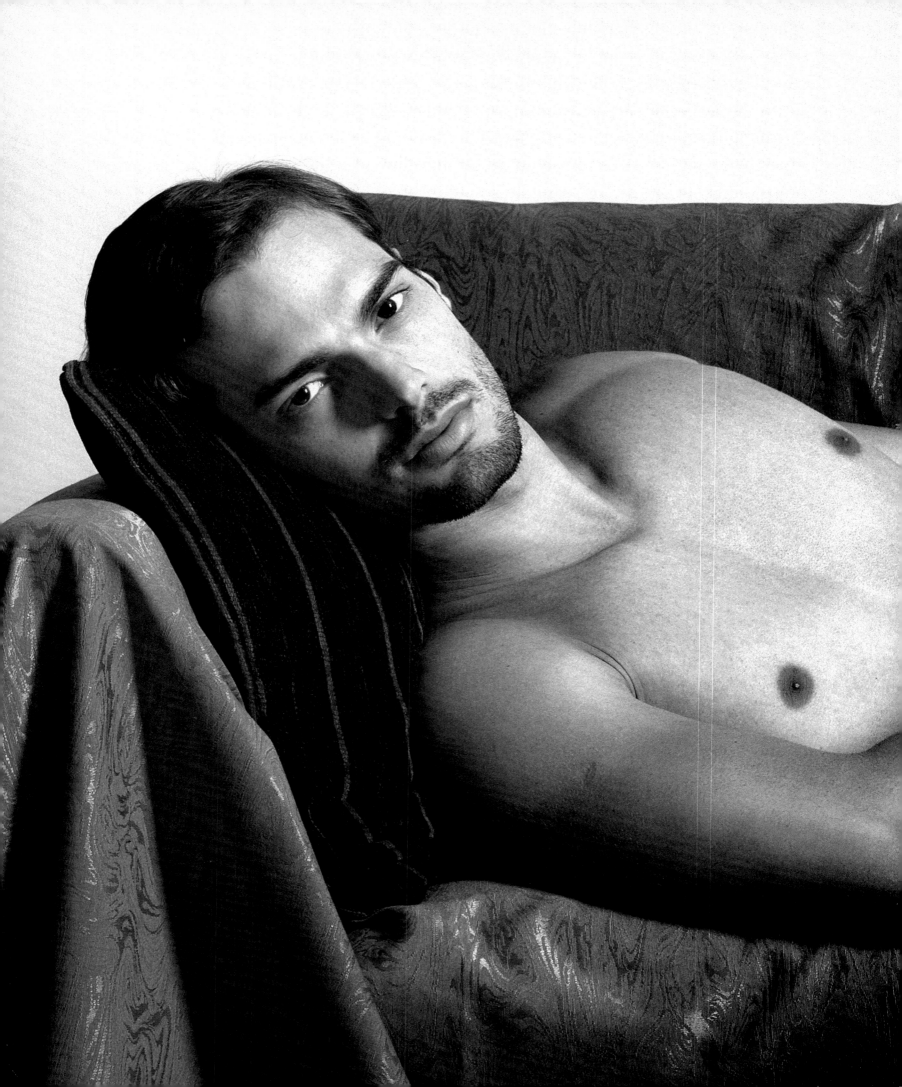

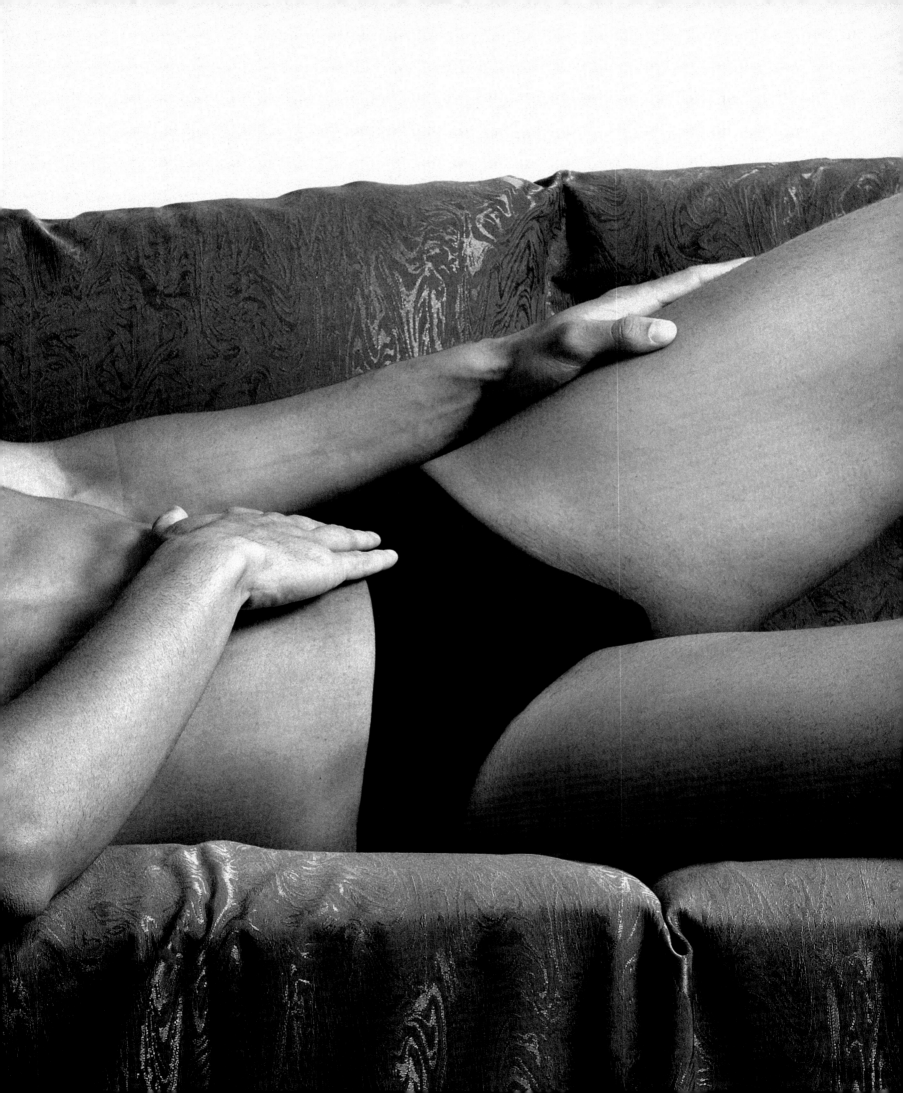

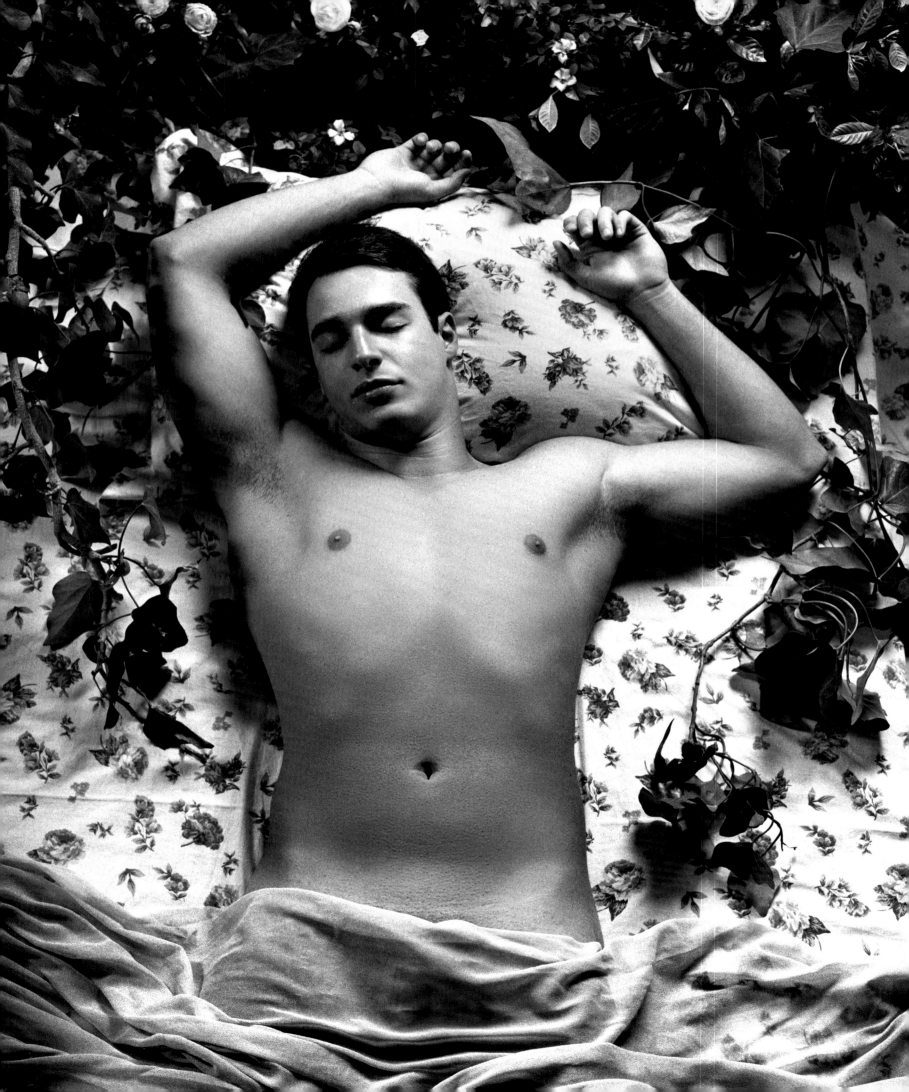

DIMITRIS YEROS

SHADES OF LOVE

PHOTOGRAPHS INSPIRED BY THE POEMS OF C. P. CAVAFY

Translated from the Greek by David Connolly

Foreword by Edward Albee

Introduction by John Wood

INSIGHT ⚙ EDITIONS

San Rafael, California

ACKNOWLEDGEMENTS

I wish to express my warmest thanks to Edward Albee for his foreword and for the love that he has shown to me and my work. To John Wood for his friendship, his excellent introduction to this book, and his unwavering support. Also to Natassa Markidou and David Leddick for their invaluable help and friendship of many years. For the same reasons, to Yiannis Patilis, Artemis Theodoridou, and Nick Lingris. And to David Connolly for the translation of Cavafy's poems, my editor Lucy Kee, my publisher Raoul Goff and all the people at Insight Editions.

I owe a special debt of gratitude to the gifted writers and artists whose photographs have made this book possible: Arman, David Armstrong, Clive Barker, Jean Baudrillard, Antonio Carmena, Chuck Close, Quentin Crisp, Leonidas Depian, Mark Doty, Olympia Dukakis, Charles Henri Ford, Carlos Fuentes, Richard Howard, Jeff Koons, Edward Lucie-Smith, Naguib Mahfouz, Vladimir Malakhov, Gabriel García Márquez, Duane Michals, Pierre and Gilles, Michel Tournier, Gore Vidal, William Weslow, Tom Wesselmann, Edmund White, and Mark Wunderlich.

For the same reason, to: Timo Schnellinger, Elias Michalolias, Antonio Beis, Dionisios Fragias, Angelo Peterson, Seraphim Houhoutas, Nikos Mavrakis and Photis Kerasidis.

My thanks also go to Stephanie, Roseanne, and Jessica, of Click Models agency in New York, for their support in finding the right models. Also to ACE Models-Greece. To Factory Café in New York, for allowing us to use their premises. To Indra Tamang, for his help in photographing Charles Henri Ford, and to all the friends and models who have posed for these photographs. Finally, to the Center for Neo-Hellenic Studies for the manuscript on page 8.

DIMITRIS YEROS

Page 2-3 **Felipe**, Athens, 2010
Page 4 **Christos**, Athens, 2008

CONTENTS

Foreword by Edward Albee 11

Introduction by John Wood 12

Plates and Poems 21

Afterword by Dimitris Yeros 157

Biographical Notes 160

Index of Proper Names 164

Index to the Poems 165

20.6.10

My life is spent in the ebb and flow of pleasure, in erotic fantasies—sometimes realized.

My work leans toward thought.

Perhaps rightly so.

Then my work is like the amphora I mentioned. It allows for different interpretations.

And my love life has its own manifestation—obscure only to the ignorant. Expressed more broadly, it may not have been enough of an artistic field for me to stay, to be enough for me.

I work like the ancients. They wrote history, they created philosophy, dramas of a mythological tragic nature— sensual—so many of them—just like me.

20.6.1910

C. P. Cavafy

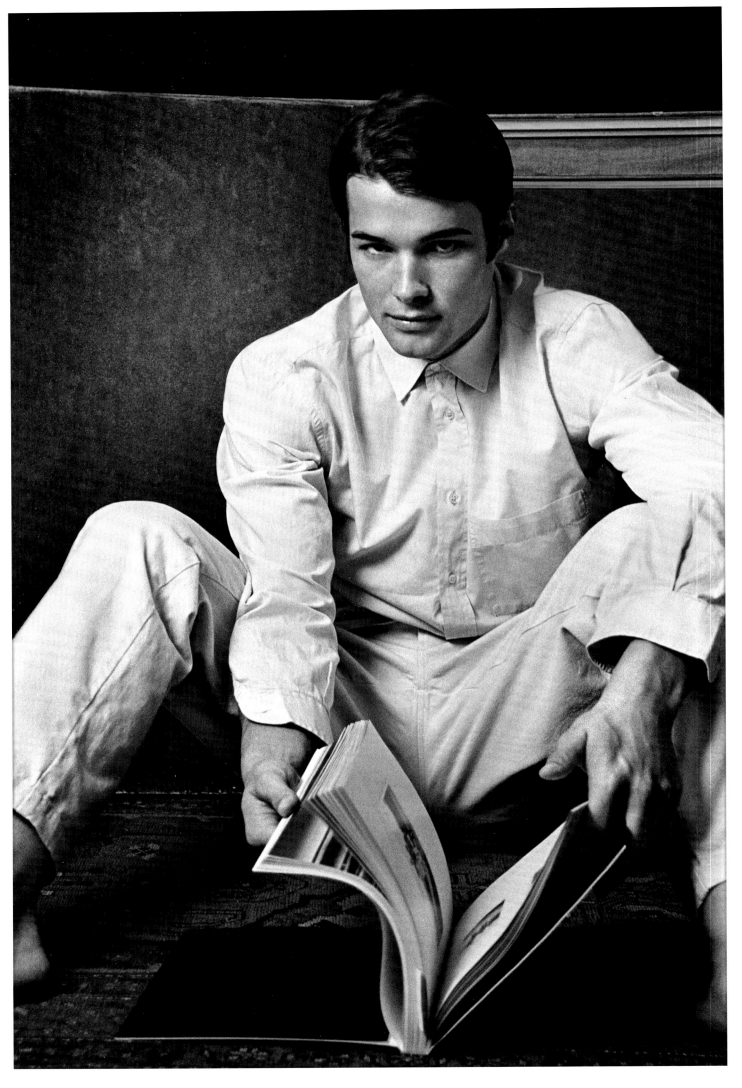

Adam, New York, 2001

I remember I began reading Cavafy when I was quite young—when all the juices which sprang from his poetry were within me as well.

I read him in translation, of course, and, first, in imperfect renderings; then, as the equivalencies improved, in better versions of the originals.

In whatever readings, I found his poetry so vivid, so personal, so beautiful, so powerful that I was aware of being in the presence of a great poet, one whose concerns echoed mine and whose mastery was thrilling.

Dimitris Yeros's splendid photographs are a fine addendum to the poems; I'm certain they would have pleased Cavafy greatly.

EDWARD ALBEE

YEROS, CAVAFY, AND THE SHIMMERING WORLD

BY JOHN WOOD

IT IS THE SENSUALITY of the male body and the exuberance of the Grecian landscape that beckons the eye of Dimitris Yeros, an internationally celebrated contemporary artist, as well-known for his paintings and sculpture as for his photographs. Like Man Ray, with whom he shares much in common, he approaches his multiple arts from radically different perspectives so that his paintings and sculpture look nothing like his photographs. Both of these artists developed an aesthetic of photography distinct and separate from their aesthetic of painting. In photography, Yeros is an acknowledged master of the nude—as was Man Ray—and his photographs, like Man Ray's, are primarily driven by the beauty of the subject and the composition. They immediately appeal to the senses and to the emotions. Yet his paintings, again like Man Ray's, are surreal and reach far beyond the world of flesh and senses. Their appeal is as immediate as the appeal of his photographs, but the appeal is to the intellect as it tries to comprehend the meaning of the strange, minimal vision he presents, a vision that immediately attracts and compels us with its spare, lean beauty. His photographs, on the other hand, present an easily comprehended vision of plenitude and richness, of the abundant world laid out lavishly, maximally, and with no questions before us.

Poet Susan Ludvigson's poem "Phantoms" concludes with these lines:

> here is the shimmering world
> within the world.

> Friends, let us not be immune
> to delight.

Her words could be a description of Yeros's photographs because they are about the shimmering world of landscapes, flowers, and the body's beauty. They are about taking delight and joy in all those things and, finally, they are a celebration of them. The best known of Yeros's photographic books, *Theory of the Nude* and *For a Definition of the Nude*, are sensual celebrations of the body, but his *Periorasis*, principally photographs of Lesbos, contains equally sensual images of water, land, and sky, as well as deeply insightful portraiture. This book of Cavafy's poems unites his various subjects and defines more clearly than before his shimmering world. It is that world within the world which Yeros captures.

Critic Paul LaRosa perceptively pointed out in his essay "Chiseled Tableaus: The Nudes of Dimitris Yeros," published in *The Journal of Contemporary Photography* (VI, 2004) that "[h]is nudes distill an unspoiled essence and vitality, discovering gestures and nuances in the body that are infinitely revealing and self-renewing. In their presence, time seems to melt away, and a world of wonder is disclosed, a world scaled both to intimacy and to universality, in which spirit and flesh harmonize." What LaRosa calls the "world of wonder" is Ludvigson's "shimmering world / within the world." LaRosa continues, "Staged to face us directly, Yeros's nudes are palpably real and teeming with presence—breathing, blinking, pulsing—but at the same time they glow like deities newly imagined."

Most photographers think, see, and create just as other visual artists do. Unique to Yeros's vision, however, is that his creative process is often like a poet's. Certainly no contemporary photographer is more "poetic" in the larger contexts of the term than Dimitris Yeros is, but he is also poetic in the smallest and most technical contexts, as well. In these photographs he does not focus on the complete poem—Cavafy's full narrative of the event—but on its most shimmering moment. These photographs then are synecdoches, classic poetic and rhetorical figures in which a part is used to suggest the whole. Poets utilize this device constantly, along with metonymy, in which a thing is replaced by something else that suggests it in richer or more complex ways. Yeros's genius is to bring to photography—which is a fresh, young, not even two-centuries-old art—the techniques of the most ancient of arts. And in so doing Yeros has created one of the most lyrical evocations of masculinity within the photographic arts.

Consider his photograph for "Days of 1901" (page 67). Few portraits could be more maximal or sensual. Yeros has laid out masculinity and male sexuality before us in all its simple allure. Because of the flowers, we initially but momentarily focus on the pubic region, then move to the face, where we linger, where we study the slightly open mouth, then move to the chest and armpit, and finally back where we began, where we do not see his sex but rather a bouquet of roses, a complex metonymy suggesting all the historical associations of roses with love and sweetness, but also thorns and blood. Even though Yeros has been completely discreet through his use of metonymy and by approaching the photograph as a portrait, the image captures and even exceeds the sensuality of George Platt Lynes, one of photography's most influential masters of masculinity and eroticism. Here is a portrayal of male sexuality, but it is just as much a portrait of a particular human being.

The face is probably more central to Yeros's photography than it is to most other photographers of the male nude; he has few nudes that are not essentially portraits. It is instructive to consider the two large Taschen anthologies of the nude: *1000 Nudes*, primarily female nudes, and *The Male Nude*. A little over 90 percent of the photographs of female nudes include their faces; however, only 60 percent of the photographs of the male nudes do. In male photography there appears to be more of a tendency to concentrate only on the most obvious sexual aspects of the body as if those aspects alone carry the sensual charge. That is not the case in Yeros's work. Of the nudes in this book and his two previous ones, 80 percent of them include the face.

Yeros understands the power and potency of this most mythic aspect of the human body. He understands that the face is the most provocative and haunting design we know, more provocative even than the curves of our flesh. He understands that there is nothing we so care to see or contemplate. The face is more than an object of mere fascination; it is the dynamo of desire—and repulsion, as well. It can generate lust or loathing before the mouth has shaped a syllable. It can blast our reason, so compel and demand, that for a look alone we may fall in love—or sometimes into disaster. A body without a face may be a mystery, but it is usually not a very hard one to solve. The face is at the center of our art; it is the focus of our ecstasy and awe; and it so dominates the visual arts that the portrait has come to be a kind of a keeper of

our myths. We all know the face of The Buddha, Socrates, Dante, and the faces of a variety of Roman emperors, sages, and saints—and we think we know the look of evil, too.

The great regard that Dimitris Yeros is held in as a portraitist is clearly demonstrated by the fact that so large a group of well-known writers, artists, and celebrities agreed to be photographed for this Cavafy project. These include Gabriel García Márquez, Naguib Mahfouz, Gore Vidal, Carlos Fuentes, Michel Tournier, Edmund White, Edward Albee, Tom Wesselmann, Arman, Chuck Close, Duane Michals, Pierre and Gilles, Quentin Crisp, Jeff Koons, Olympia Dukakis, and others.

The mark of the great portrait is three-fold—we are convinced we know the sitter, that he or she has been captured in some essential or revealing way, and that as personal as the portrait might be, something common to us all is represented there, too. Our trust in this revelation is our measure of the artist's greatness. A Yeros nude or a formal Yeros portrait never disappoints us in any of those three ways.

Look at the portrait of Mebes of Antioch (page 115). In Cavafy's poem he is the "comeliest youth . . . the most beloved" and well-paid "in all Antioch." Yeros poses him not in antiquity but in our own time, and his look is of a modern, self-assured hustler comfortable with his body and in no doubt about his charms. Some of us may be less assured of our charm or less comfortable with our bodies than he, but he possesses an insouciance common to all our dreams. We know his look well, if only for the fact we wish it were ours. At every point Yeros's rich synecdoches reverberate with multiple meanings, suggestions, and allusions. It is finally Everyman that we see in these images—brother, son, father, husband, lover, enemy, artist, friend, craftsman—rendered as no other photographer has rendered them before into a poetry that shimmers and summons us to delight in the same way that the poetry of Cavafy shimmers and summons.

Even before beginning this book Yeros caught the poetry and voice of Cavafy in his photographs. Yeros's principal subject, like Cavafy's, is beauty—beauty seen though the body and recaptured in memory and in art. Consider Cavafy's poem "I've Looked So Much" on page 116:

> I've looked so much upon beauty
> that my vision is replete with it.

Though Yeros is one of photography's great sensualists and Cavafy one of modern poetry's, neither gives himself over solely to the body. Land, sky, flowers, and the things of the world are all woven into larger evocations of passion and desire (page 31).

Constantine Cavafy was born in Alexandria on April 29, 1863 and died there in 1933 on his seventieth birthday. Though he had literary admirers during his life time, such as E. M. Forster, Harold Acton, W. H. Auden, and T. S. Eliot, his recognition as the greatest modern poet writing in Greek or, as he has also been called, the greatest Mediterranean poet of modern times has come in the last half century with the publication of all of his poems and their translation into many languages. This elegant new translation by David Connolly was specifically created for this volume of Yeros's photographs.

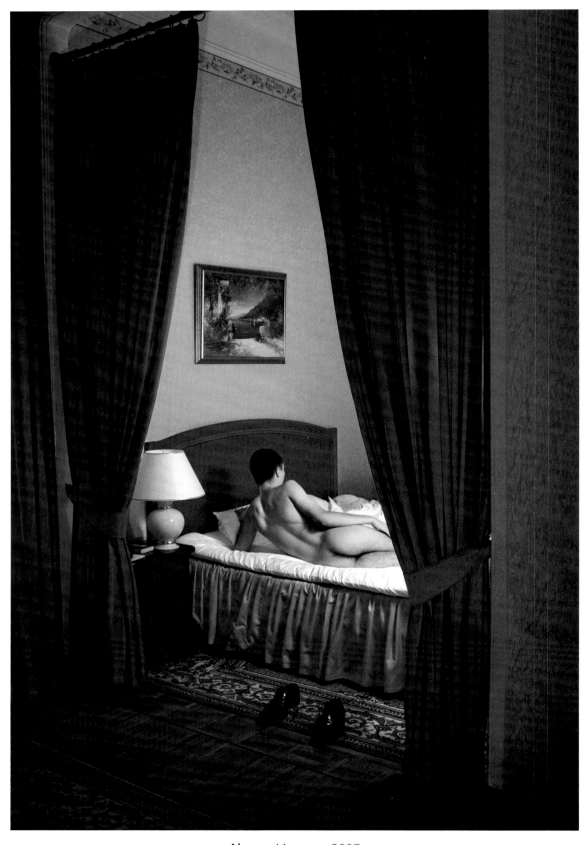

Alexey, Moscow, 2007

Of the great poets of the past century, only W. B. Yeats is as sensitive as Cavafy to the themes of desire, memory, and aging, all of which are in constant counterpoint one with another in Cavafy's poems, as they are in Yeats's late work. As Cavafy wrote in "To Remain" and Yeros captured in his photograph (page 85):

> It must have been one in the morning,
> or half-past one.
>
> In a corner of the tavern;
> behind the wooden partition.
> The place was completely empty save for the two of us.
> An oil-lamp provided scant light.
> The drowsy waiter was dozing by the door.
>
> No one would have seen us. Yet already
> we were so aroused,
> that we'd become incapable of caution.
>
> Our clothes were half-open—not that there were many
> for the divine month of July was blazing hot.
>
> Pleasure of the flesh through
> the half-open clothes;
> quick baring of the flesh—the image of which
> crossed twenty-six years; and has come now
> to remain in this poetry.

In both Cavafy and Yeros these themes of desire and memory are played out against bodies of perfect beauty, against those Grecian models of perfect, "plummet-measured face[s]" which boys and girls rise from "solitary beds" to kiss "at midnight in some public place," as Yeats described them in "The Statues." Yeats concludes that poem by invoking us, as Cavafy and Yeros always do, to "Climb to our proper dark, that we may trace / The lineaments of a plummet-measured face."

But one's "proper dark" is not always an easy place to find, to face, or to climb to. It involves both emotional and artistic honesty, the kind of honesty one finds in Cavafy's well-known "The Bandaged Shoulder" and its accompanying photograph (page 125). And we can see a similar honesty in the poem and photograph "One Night" (pages 42-43).

These are, of course, eternal themes found throughout art, but they have usually been reserved for expressions by men about women. Today, however, is a time that has come to respect and value both sexual equality and biological explanations of human sexuality instead of the explanations of ancient religions obsessed with procreation and increase. But in Cavafy's time, even though years after Walt Whitman's, such open expressions in poetry were still relatively rare because of the police power of those determined to enforce their sexual tastes and

notions of morality upon others. Today this strikes us as repellent. The history of the world, however, has never been the history of progress, as the nineteenth and twentieth centuries would have us believe. The world's history has been an unfortunate chronicle of waves of ignorance sweeping over us in cycles of human stupidity. Intolerance will, of course, return; it always has. But there will also always be Cavafys somewhere to remind us of the beauty and complexity of true human nature. As Cavafy wrote in his prose poem, "The Regiment of Pleasure":

> All the laws of morality—badly devised and badly applied—are worth nothing and cannot for a moment hold their own when the Regiment of Pleasure marches by with music and flags. Do not allow any shady virtue to restrain you. Do not believe that any obligation binds you. Your duty is to yield, always to yield to the Desires, those most perfect creations of the perfect gods. Your duty is to enlist as a faithful soldier, with simplicity of heart, when the Regiment of Pleasure marches by with music and flags. . . . Service in pleasure is a never-ending joy. It exhausts you, but it does so with divine intoxication. And when at last you collapse en route, yours is still an enviable lot. When your funeral procession passes by, the Forms created by your desires will shower your coffin with lilies and white roses, the young Gods of Olympus will carry you on their shoulders, and they will bury you in the Cemetery of the Ideal, where the white mausoleums of poetry shine bright.

After reading *Les Fleurs du mal*, the book which was the genesis of modern poetry, Victor Hugo wrote poet Charles Baudelaire, "*Vous dotez le ciel de l'art d'un rayon macabre, vous créez un frisson nouveau.*" "You endow the sky of art with a macabre gleam, you create a new thrill [or shiver]." Cavafy brought a similar *frisson nouveau* to his poetry because he approached his passion with far greater frankness than Whitman had his. In transforming and modernizing one of art's classic themes, he, like Baudelaire, brought to his poetry a new edge. And that frisson—that thrill and edge—was his complete lack of shame in his art at what he felt. Consider "He Came to Read" (page 99):

> He came to read. Still open are
> two or three books; historians and poets.
> But he read for barely ten minutes,
> and put them aside. He's dozing
> on the sofa. Books are his whole life—
> but he's twenty-three, and exceedingly handsome;
> and this afternoon desire passed
> into his perfect flesh, his lips.
> Into his flesh which is sheer beauty
> desire's glow passed;
> no foolish shame for the kind of pleasure . . .

This emotion and its frank presentation was not completely new, but it had rarely been seen since the Renaissance and the sexual frankness one finds in the sonnets of William Shakespeare and Richard Barnfield. Shakespeare scholar Stephen Greenblatt, in his recent book *Will in the World: How Shakespeare Became Shakespeare*, explained that the Elizabethan age "acknowledged the existence of same-sex desire," found it "in a certain sense easier for them to justify than heterosexual desire," and realized "it was perfectly understandable that men would love and desire men" (253).

Cavafy's openness gave his poetry its frisson and that sexual openness is what is usually associated with his work; however, he is not merely a poet of love's body. His world view is far more complex. As I suggested earlier, desire, memory, and aging are principal subjects in his work, as they are in the work of Yeats. But his work is far sadder than Yeats's. Yeats clearly regretted his loss of sexual vitality. In one of his last poems, entitled "Politics" and probably written in that most fateful of political years, 1939, Yeats wrote, "How can I, that girl standing there, / My attention fix / On Roman or on Russian / Or on Spanish politics." He admits that what they say "Of war and war's alarms" may be true, "But O that I were young again / And held her in my arms." There is both a fierceness and a kind of consolation in Yeats's last work. In another of the final poems he wrote, "Maybe at last being but a broken man / I must be satisfied with my heart." And he concludes saying that he "must lie down . . . / In the foul rag and bone shop of the heart."

Neither fierceness nor consolation are part of Cavafy's vision; he is far more contemporary in his tone. Though he shares several great themes with Yeats, his voice is often like the bitterly realistic voice of Philip Larkin, one of England's greatest poets of the past century. This is Cavafy but it reads like Larkin (page 28):

> Half past twelve. The time has passed quickly
> since nine o'clock when I lit the lamp,
> and sat down here. I've been sitting without reading,
> and without talking. Who would I talk to
> all alone as I am in this house.
>
>
>
> The image of my youthful body
> came and brought me sorrows too;
> family bereavements, separations,
> feelings of those dear to me, feelings
> of the dead so little appreciated.
>
> Half-past twelve. How the time has passed.
> Half-past twelve. How the years have passed.

Were this in rhyme, it could easily pass for Larkin, as could these passages from several other of Cavafy's poems:

> The days gone by remain behind,
> a dismal line of extinguished candles;
> those nearest are still smoking,
> cold candles, melted and bent. (page 54)

> Each monotonous day is followed
> by another identical one. The same things
> will happen, and will happen again—
> these like moments find us and leave us. (page 142)

> In their aged, wasted bodies
> dwell the souls of old men.
> How pitiful the poor things are
> and how weary of the wretched life they lead.
> How they trembled lest they lose it and how they cherish it
> these confounded and contradictory
> souls—so tragicomical—that dwell
> in their aged, ravaged hides. (page 60)

Probably Cavafy's true *frisson nouveau* was not his sexual frankness but his Larkinesque negativity, irony, and boredom. That was a truly new element lacking either consolation or fierceness but something contemporary man has emotionally responded to. In spite of their negativity both Larkin and Cavafy could touch something essential in contemporary experience because within that negativity still glimmered the shimmering world. In "Sad Steps," a poem about waking at night and looking at the moon from Larkin's last book, he wrote:

> One shivers slightly, looking up there.
> The hardness and the brightness and the plain
> Far-reaching singleness of that wide stare
>
> Is a reminder of the strength and pain
> Of being young; that it can't come again,
> But is for others undiminished somewhere.

Larkin touches us, even shimmers us, in those words, just as Cavafy does in his, and as Dimitris Yeros, that most sensitive and articulate translator of Constantine Cavafy, does in his rendering of Cavafy's poetry into the universal language of photography.

PLATES

AND

POEMS

MORNING SEA

Let me stop here. And let me too view nature awhile.
The morning sea's and cloudless sky's
brilliant blues, and a yellow shore; all
beautiful and immensely bright.

Let me stop here. And let me fool myself that I see them all
(I did see them for a moment when first I stopped);
and not here too my fantasies,
my memories, the visions of sensual delight.

Zacharias, Lesbos Island, 2002

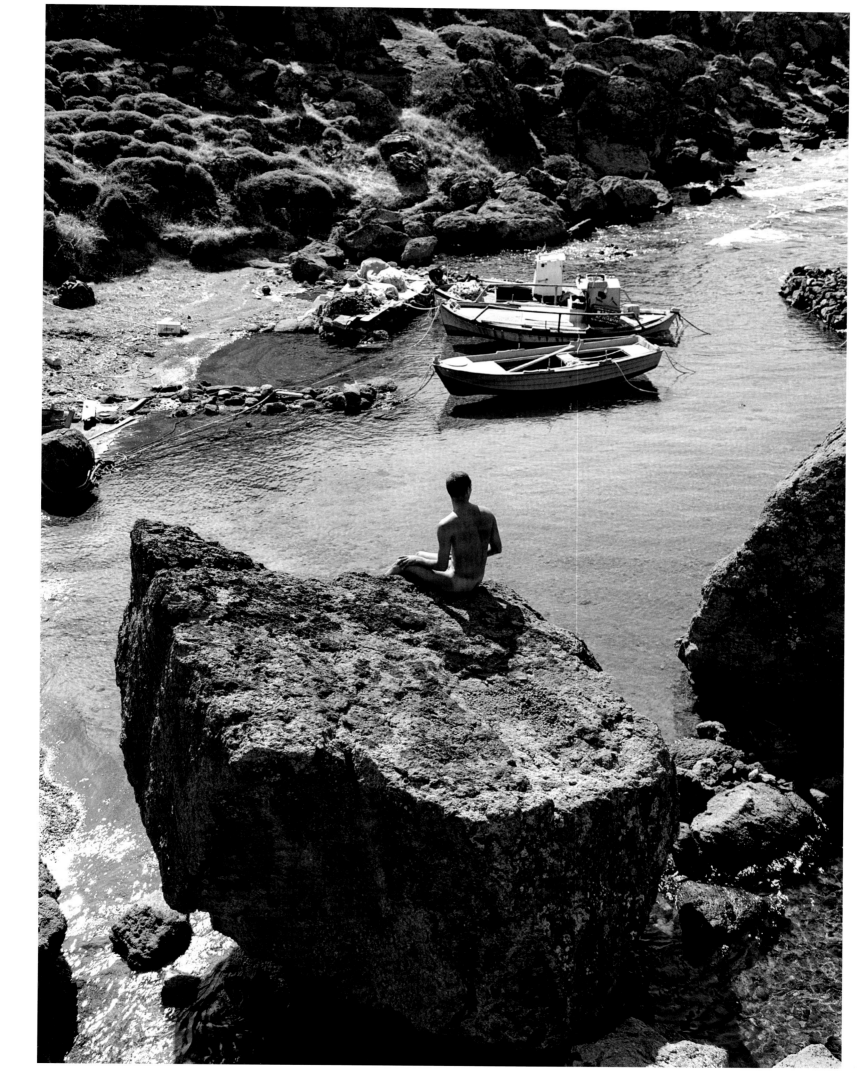

ITHACA

As you set out bound for Ithaca,
hope that the journey is a long one,
full of adventures, full of learning.
Of the Laestrygonians and Cyclopes,
of wrathful Poseidon have no fear,
you'll never meet such like on your journey,
if your thoughts remain lofty, if noble
sentiment grips your body and spirit.
You'll never encounter raging Poseidon,
Laestrygonians and Cyclopes,
unless you bear them in your soul,
unless your soul sets them before you.

Hope that the journey is a long one.
That the summer morns be many
when with what delight, what joy
you enter harbors hitherto unseen;
that you stop at Phoenician markets,
and acquire fine merchandise,
nacre and coral, amber and ebony,
and all kinds of heady perfumes,
as many heady perfumes as you can;
that you visit many Egyptian cities,
to learn and learn from the erudite.

Always keep Ithaca in mind.
To arrive there is your destination.
But in no way rush the voyage.
Better for it to last many years;
and for you to berth on the isle an old man,
rich with all you gained on the journey,
without expecting Ithaca to give you riches.

Ithaca gave you the wonderful voyage.
Without her you would not have begun the journey.
Yet she has nothing more to give you.

And though you may find her wanting, Ithaca has not deceived you.
Wise as you've become, with such experience,
you'll have already understood what these Ithacas mean.

Gabriel García Márquez, Mexico City, 2006

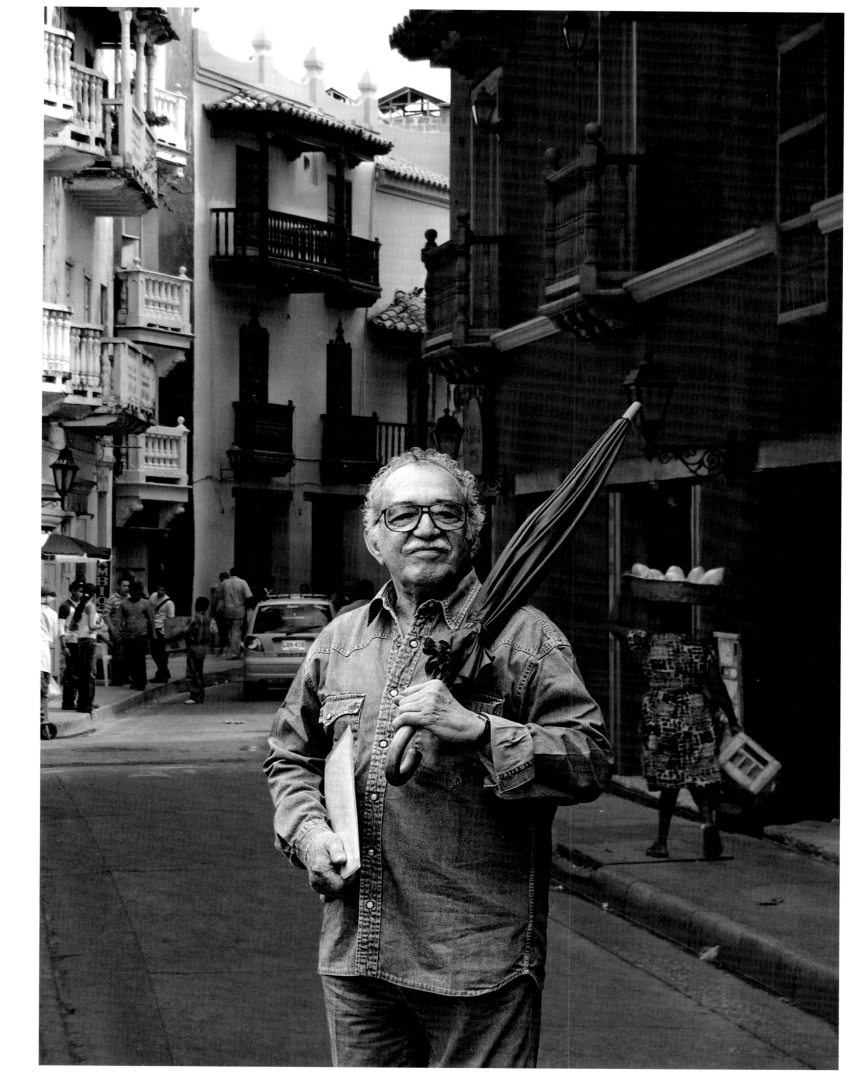

I sit and muse. Desires and senses
are what I brought to Art— things half-glimpsed,
faces or lines; of unfulfilled loves
a few vague memories. I'll give myself to it.
It knows how to shape Beauty's Form;
almost imperceptibly complementing life,
combining impressions, combining the days.

Edward Albee, New York, 2002

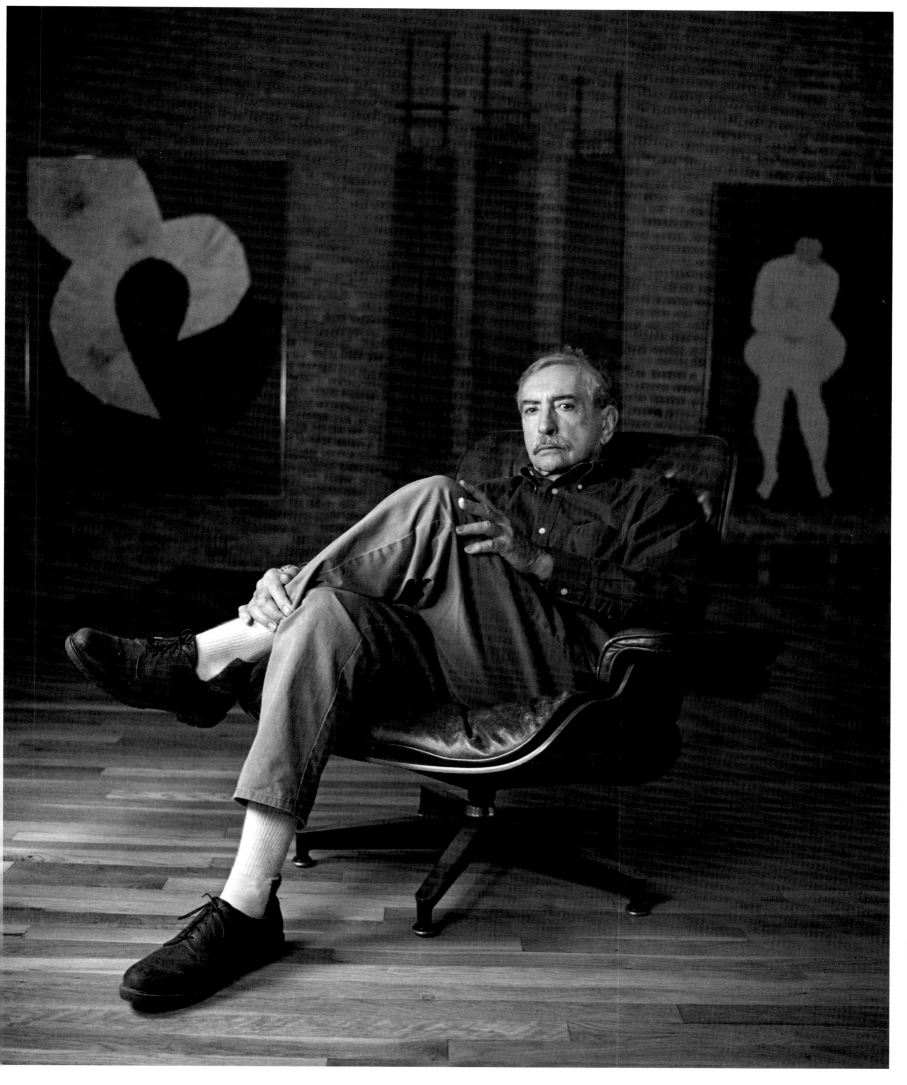

SINCE NINE O'CLOCK—

Half past twelve. The time has passed quickly
since nine o'clock when I lit the lamp,
and sat down here. I've been sitting without reading,
and without talking. Who would I talk to
all alone as I am in this house.

At nine o'clock when I lit the lamp,
the image of my youthful body
came and found me and reminded me
of locked perfumed rooms,
and pleasure long past—what shameless pleasure!
And it also conjured up before my eyes,
streets no longer recognizable,
busy clubs now closed,
and theatres and cafés that are no more.

The image of my youthful body
came and brought me sorrows too;
family bereavements, separations,
feelings of those dear to me, feelings
of the dead so little appreciated.

Half-past twelve. How the time has passed.
Half-past twelve. How the years have passed.

Leonidas Depian and Vladimir Malakhov, Athens, 2002

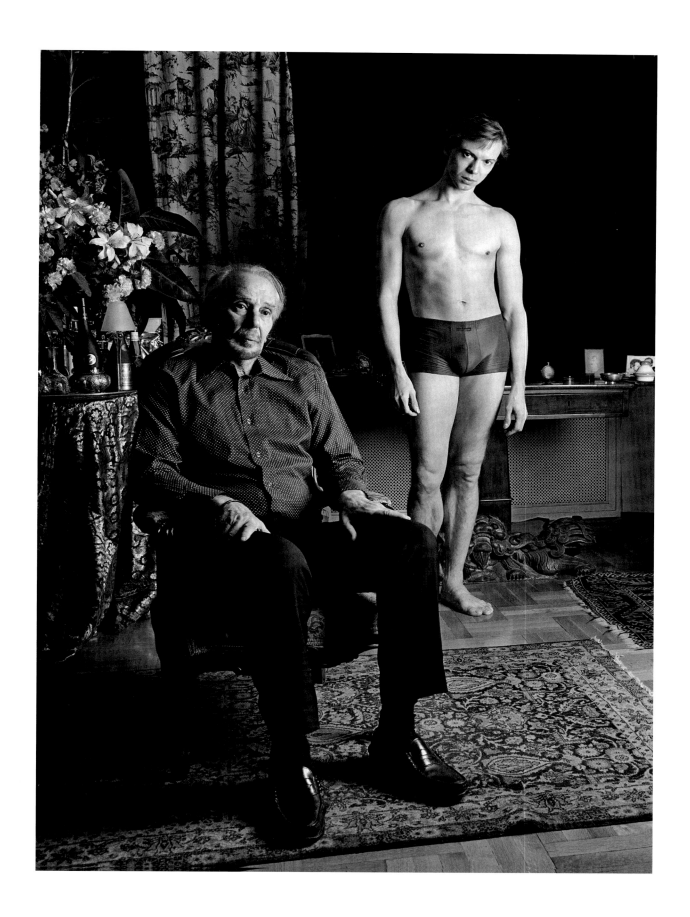

CRAFTSMAN OF CRATERS

Upon this crater of pure silver—
crafted for the household of Heracleides,
in which good taste in abundance prevails—
note the elegant flowers, and streams, and thyme,
and at the centre I have set a fair youth,
naked, amorous; one of his legs still
half in the water.— I begged you, o memory,
to be my prized assistant that I might fashion
just as it was the face of the youth I loved.
The task proved considerable for
some fifteen years have passed since the day
he fell, a soldier, in the defeat at Magnesia.

Sakis, Lesbos Island, 2006

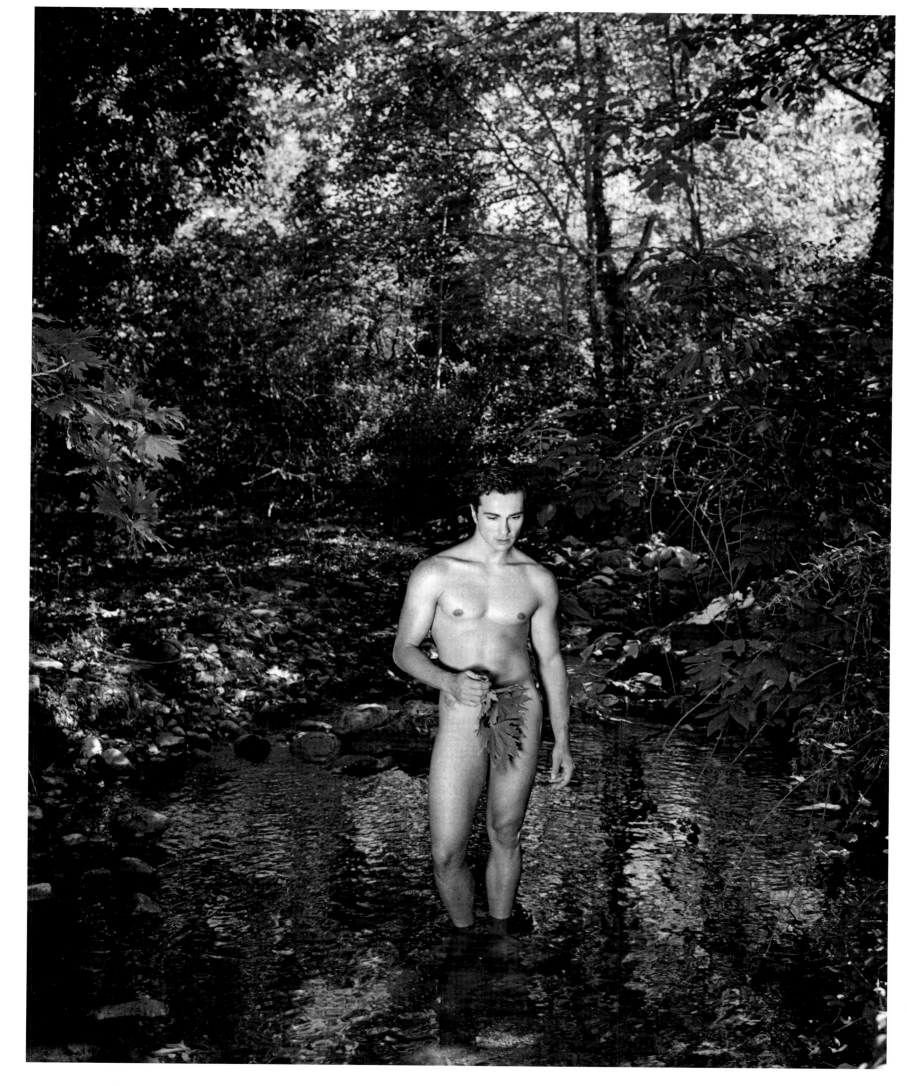

SEPTEMBER 1903

Let me at least fill myself with delusion now;
that I might not feel my life empty.

So many times I was so close.
Yet how paralyzed, how fainthearted I was;
why was it I remained with lips sealed;
my empty life weeping within me,
and my desires garbing themselves in black.

So many times to be so close
to those eyes, to those sensual lips,
to that exquisite, beloved body.
So many times to be so close.

Diego Centeño, Athens, 2005

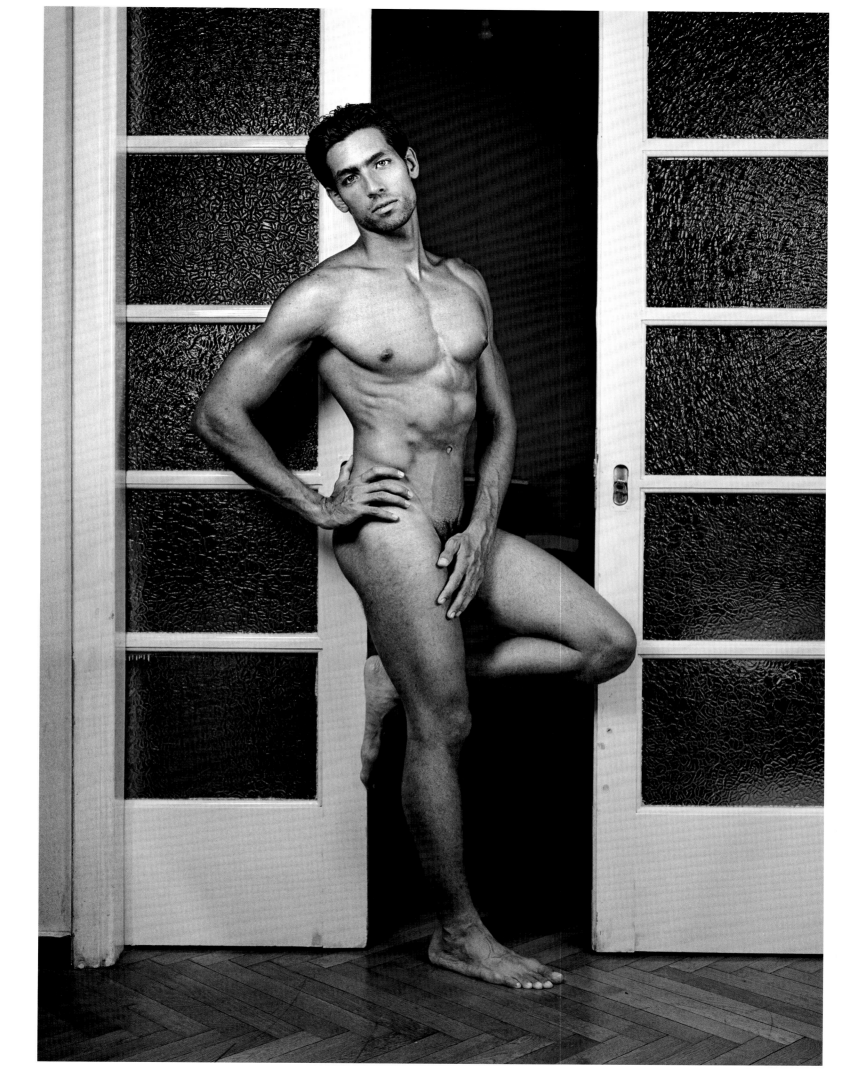

VOICES

Ideal voices and ones we loved
of those who died, or those who
like the dead are lost to us.

Sometimes in dreams they speak to us;
sometimes in thought the mind hears them.

And briefly at their sound return
sounds from our lives' first poetry—
like music, at night, that fades, far away.

Richard Howard, New York, 2001

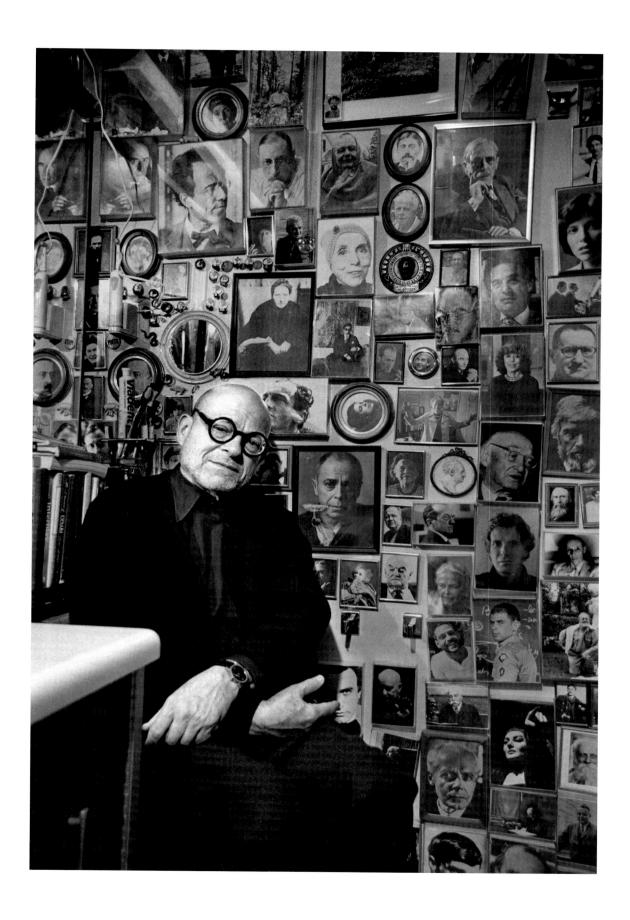

THAT'S WHAT

In this obscene photograph sold
secretly (lest the policeman see) in the street,
in this salacious photograph
how did such an exquisite face
come to be; how did you come to be here.

Who knows what a cheap, sordid life you must lead;
how awful the surroundings must have been
when you posed to have this photograph taken;
what an abject soul yours must be.
Yet despite all this, and more, for me you are
that exquisite face, that figure
fashioned and intended for pleasure peculiarly Greek—
that's what you are for me and why my poetry speaks of you.

Mark Doty, New York, 2001

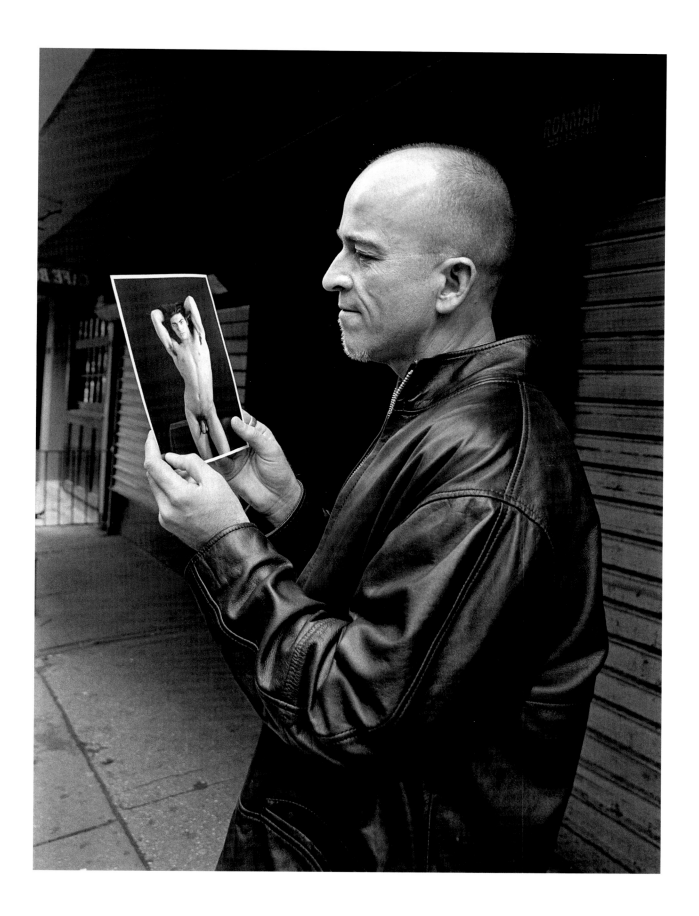

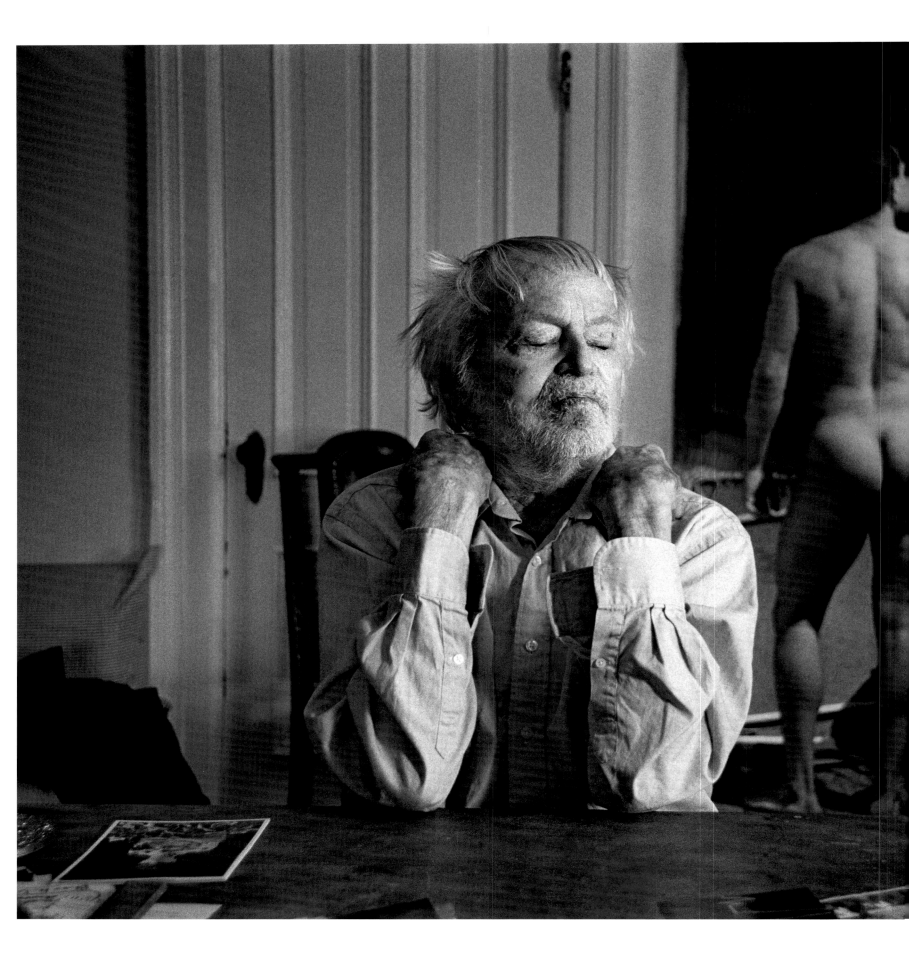

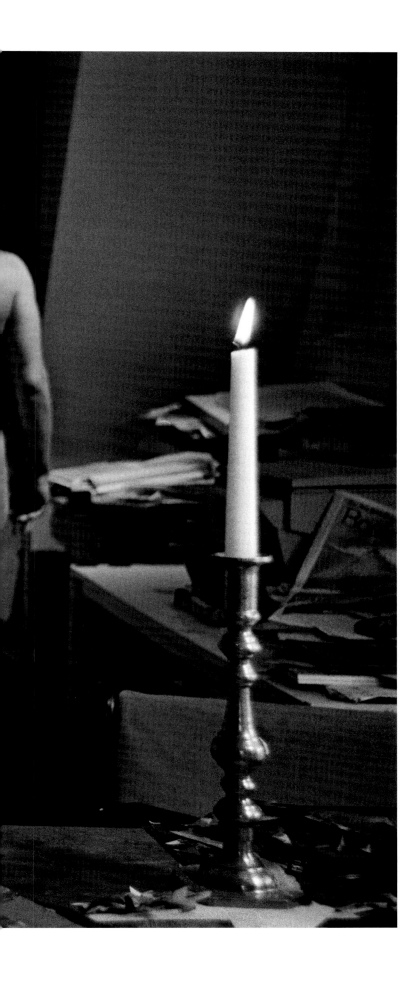

SO THEY MAY COME—

One candle is sufficient. Its dim light
is better suited, will be more congenial
when the Shades come, the Shades of Love.

One candle is sufficient. Tonight the room
should not have too much light. Lost in reverie
and evocation, and with the scant light—
lost in reverie thus I'll conjure up visions
so the Shades may come, the Shades of Love.

Charles Henri Ford, New York, 2001

I'd like to put this memory into words . . .
But it's faded now . . . almost nothing remains—
for it goes far back, to the first years of my youth.

Skin as though of jasmine . . .
That night in August—was it August?—
I can barely recall the eyes; blue I think they were . . .
Yes, blue; sapphire blue.

Rodrigo and Dante, New York, 2006

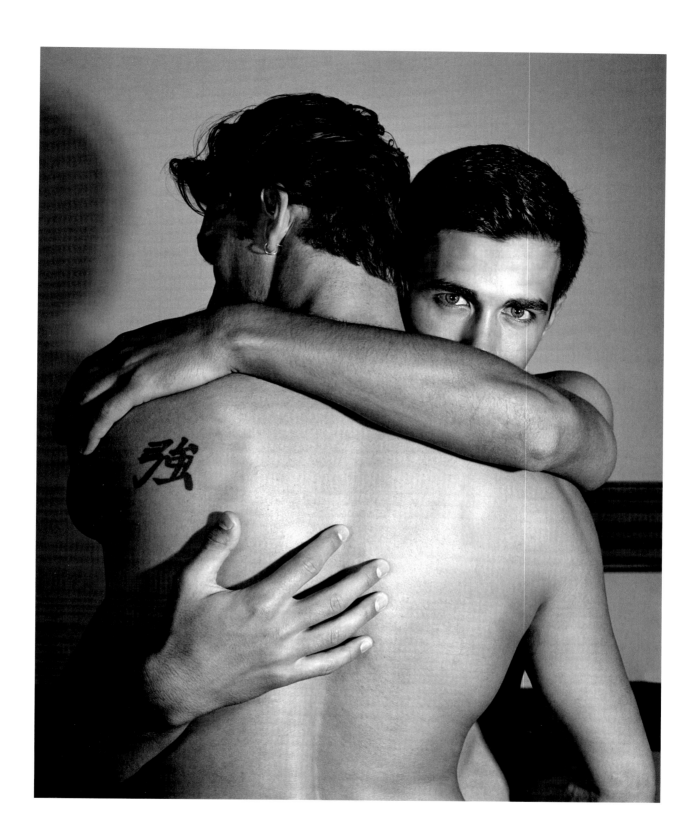

ONE NIGHT

The room was cheap and sordid,
tucked away above the shady tavern.
The window looked onto the back street,
a dirty narrow one. From below
came the voices of some workmen
playing cards and carousing.

And there, on that common, lowly bed
I experienced love's body, experienced
ecstasy's sensual and rosy lips—
rosy lips of such ecstasy, that even now
as I write, after so many years,
in my lonely house, I'm in ecstasy again.

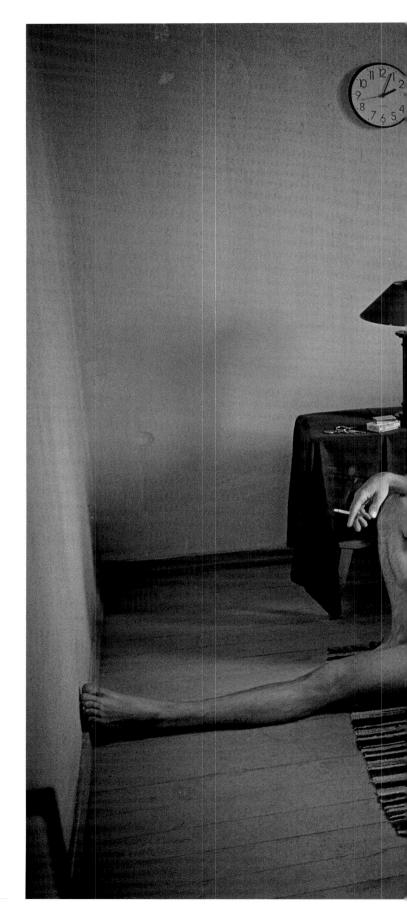

P. and J., Lesbos Island, 2000

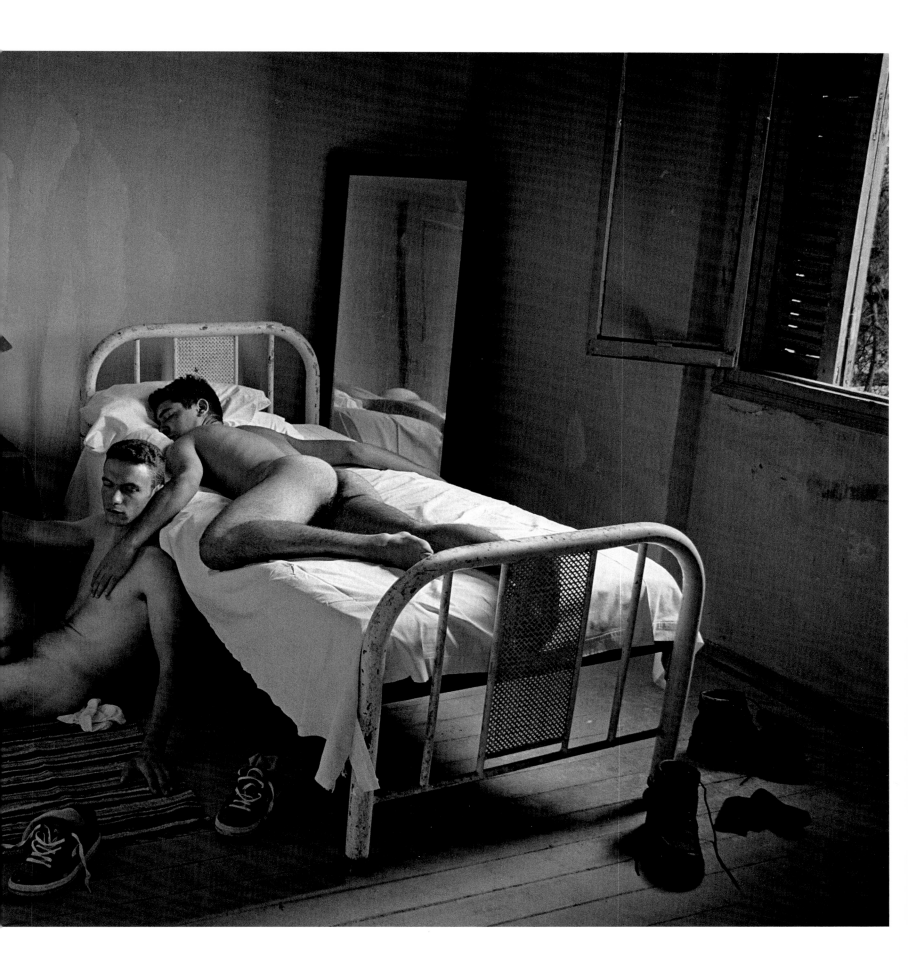

THEATRE OF SIDON (A.D. 400)

An upright citizen's son— above all, a comely
young man of the theatre, in many ways agreeable
I sometimes compose in the Greek tongue
quite racy verses, that I circulate
secretly, needless to say— God forbid that they be seen
by those who dress in grey, the preachers of morality—
verses on sensuality of a singular kind, that leads
to a love both barren and condemned.

Mark Wunderlich, New York, 2002

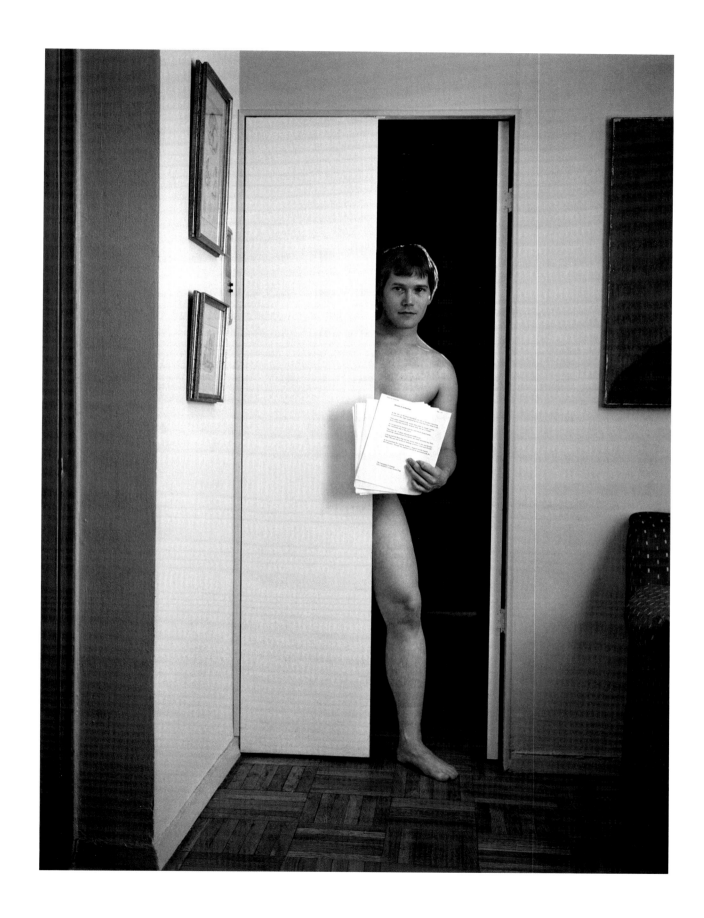

PASSING THROUGH

What as a schoolboy he shyly imagined is open,
set forth before him. And he gads around, is out all night,
and gets carried away. And as is only right (for art of our kind),
sensuality delights in his blood,
his fresh hot blood. His body is overcome
by illicit sexual ecstasy; and the youthful
limbs are given up to it.
 And so an ordinary lad
becomes worthy of our attention, and for a moment
this sensuous lad with his fresh hot blood
passes too through Poetry's Lofty World.

Jason, Athens, 2003

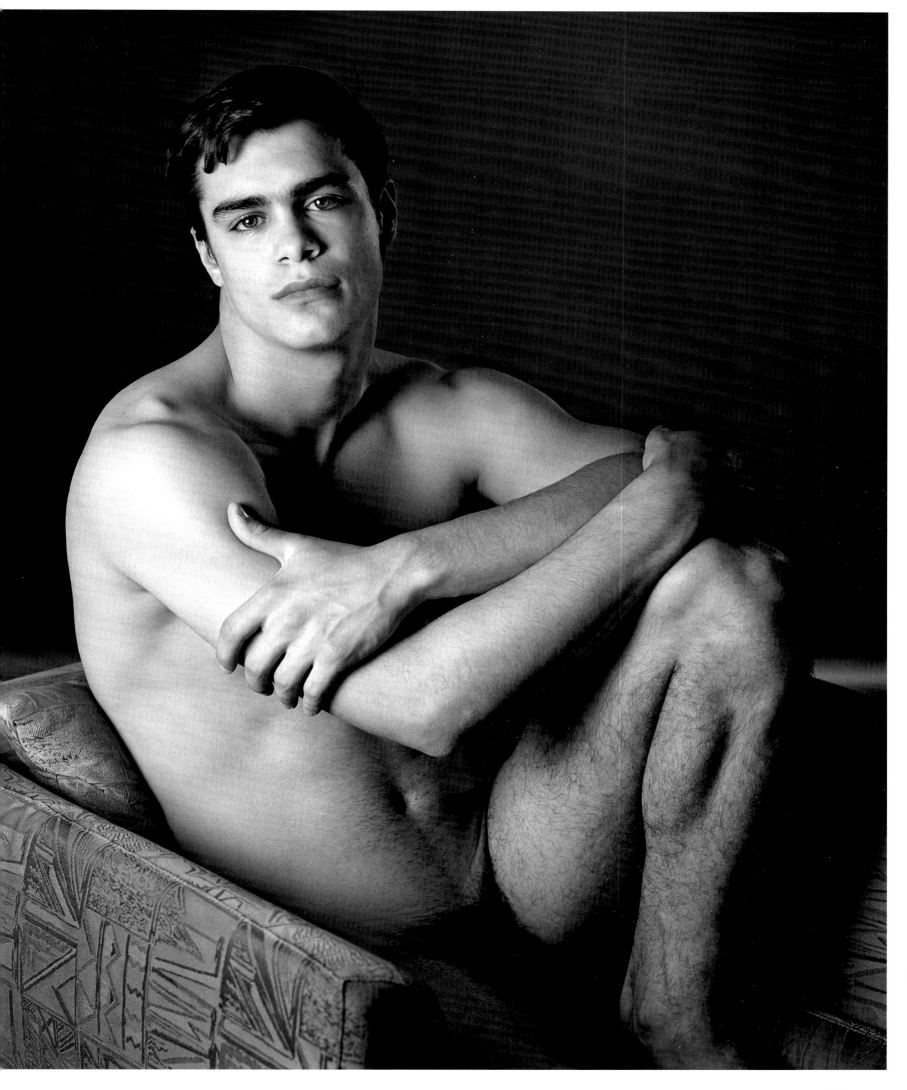

REMEMBER, BODY . . .

Body, remember not only how much you were loved,
not only the beds on which you lay,
but also those desires that for you
shone plainly in the eyes,
and trembled in the voice—and that
some chance impediment frustrated.
Now that all these are long in the past,
it almost seems as though you surrendered
to these desires too—how they shone,
remember, in the eyes that gazed at you;
how they trembled in the voice, for you, remember, body.

William Weslow, New York, 2001

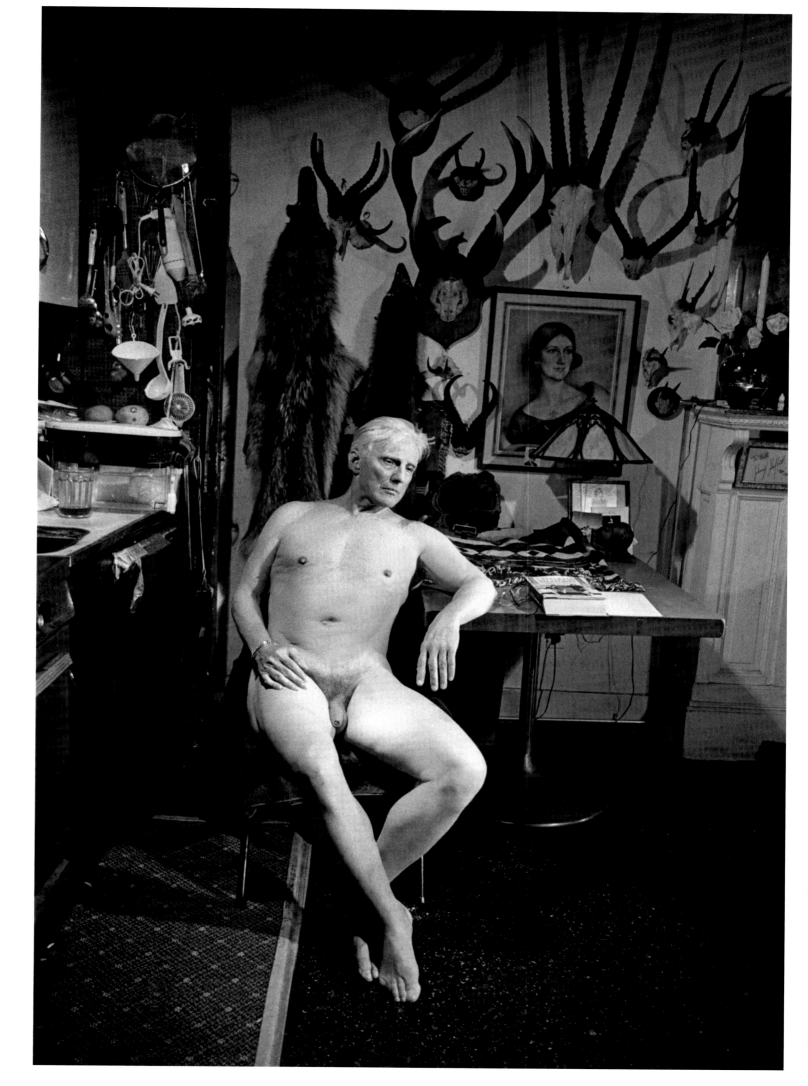

IN AN OLD BOOK—

In an old book—a hundred or so years' old—
forgotten between the pages.
I found an unsigned aquarelle
No doubt the work of a rather able artist.
It bore the title, "Depiction of Love".

Though "—of love's ultimate aesthetes" would have been more apt.

For it was plain on looking at the work
(the artist's intention was easily discerned)
that one who loves in quite wholesome ways,
bound by what is altogether permissible,
was not to be the destiny of the youth
in the painting—with dark chestnut-colored eyes;
with his face's singular beauty,
the beauty of perverse attractions;
with his perfect lips that bring
rapture to a beloved's body;
with his perfect limbs created for beds
that current morality calls shameless.

Edmund White, New York, 2002

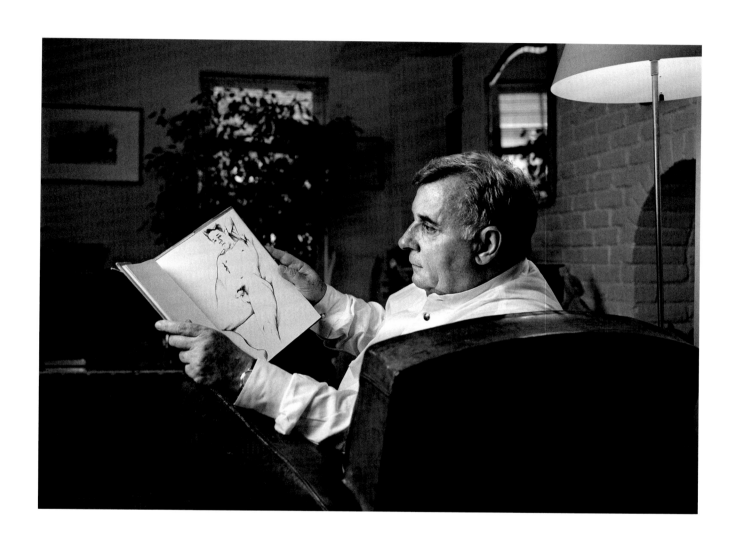

BIRTH OF A POEM

One night when the moon's fair light
flowed into my bedroom . . . imagination, borrowing
something from life: the smallest of things—
a long-past scene, a long-past pleasure—
brought its own image of flesh,
its own image to a bed of love . . .

Felipe, Athens, 2010

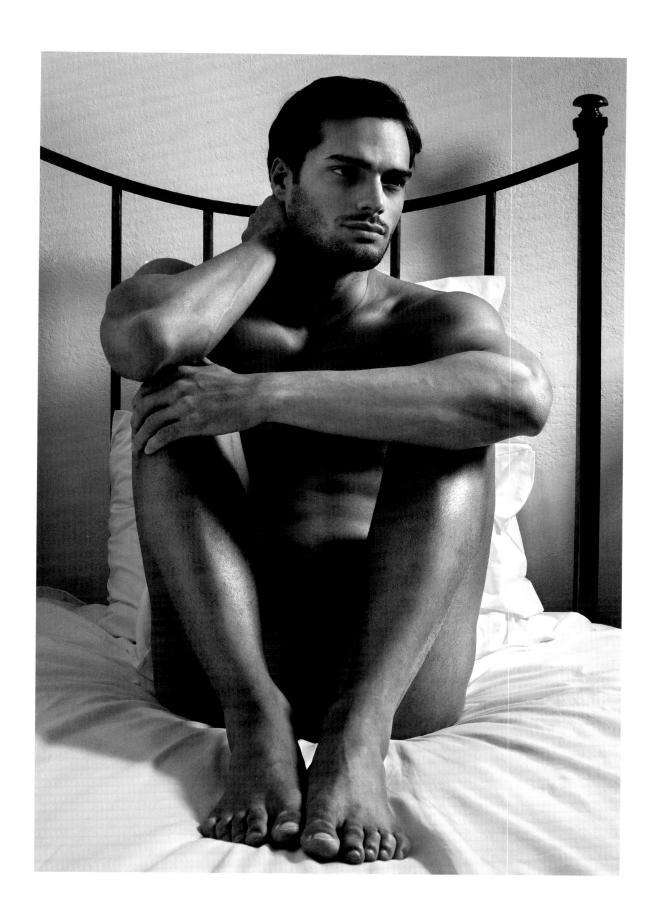

CANDLES

The days to come stand before us
like a row of little lighted candles—
golden candles, warm and vibrant.

The days gone by remain behind,
a dismal line of extinguished candles;
those nearest are still smoking,
cold candles, melted and bent.

I've no wish to see them; their shape saddens me,
and it saddens me to recall their first light.
I look ahead at my lighted candles.

I've no wish to turn lest horrified I see
how quickly the dark line lengthens,
how quickly the extinguished candles multiply.

Michel Tournier, Paris, 2002

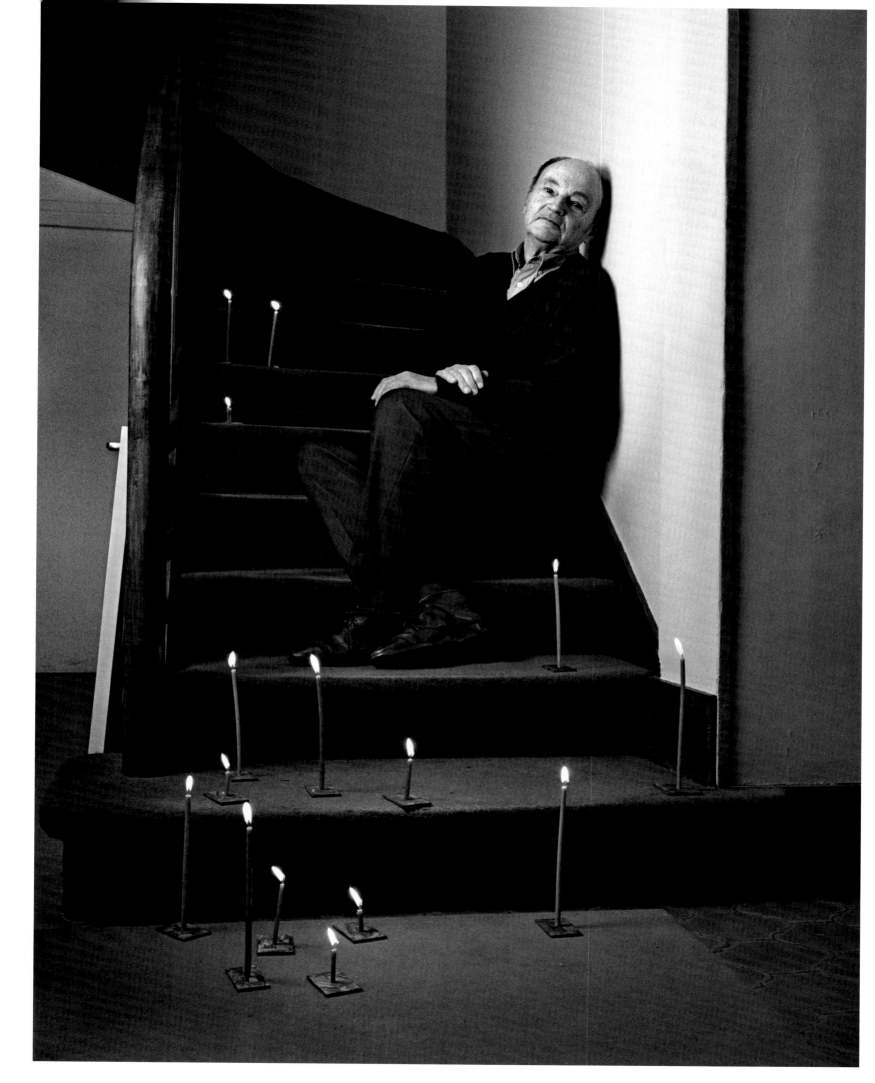

IN THE BORING VILLAGE

In the boring village where he works—
an assistant in a general store;
still very young—and where he's waiting
for two or three months more to pass,
two or three months more, for work to slacken,
so he can go into town and fling himself
without delay into the activity and fun;
in the boring village where he waits—
he went to bed tonight beset by passion,
all his youth aflame with desires of the flesh
all his exquisite youth in exquisite intensity.
And in his sleep sensual pleasure came;
in sleep he sees and possesses the figure, the flesh he so craved . . .

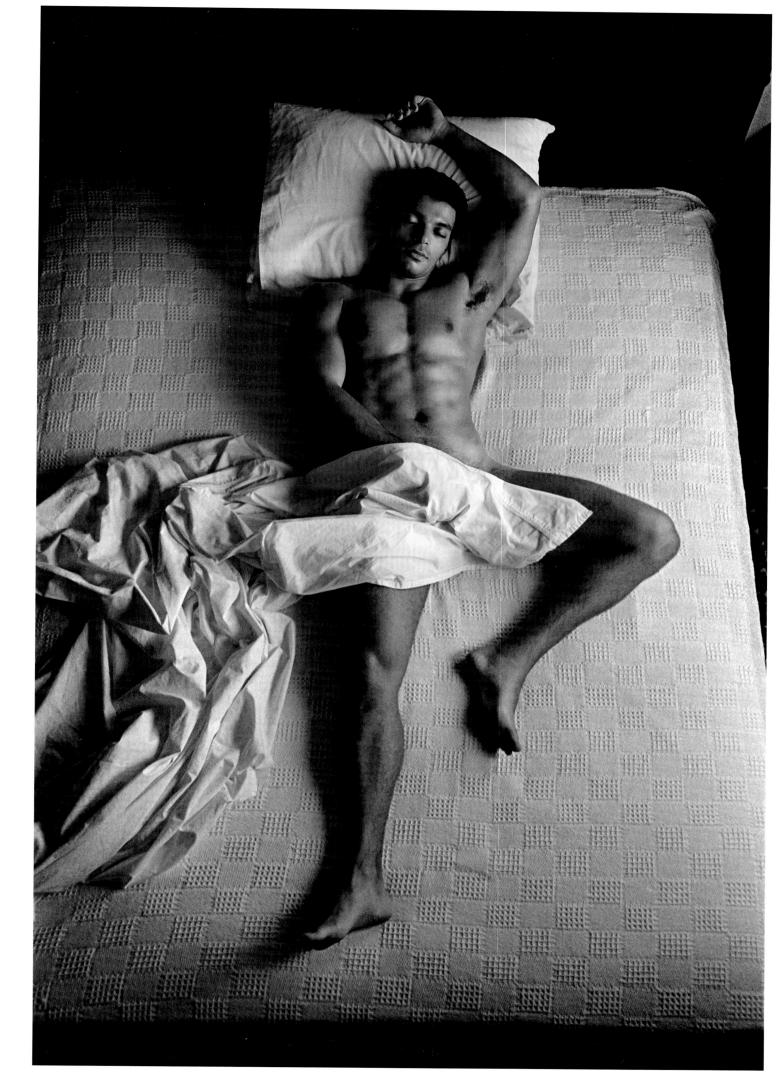

RETURN

Return often and take hold of me,
cherished sensation, return and take hold of me—
when the body's memory awakens,
and past desire again runs through the blood;
when the lips and skin remember,
and the hands feel as though they touch again.

Return often and take hold of me at night,
when the lips and skin remember . . .

John Wood, New York, 2001

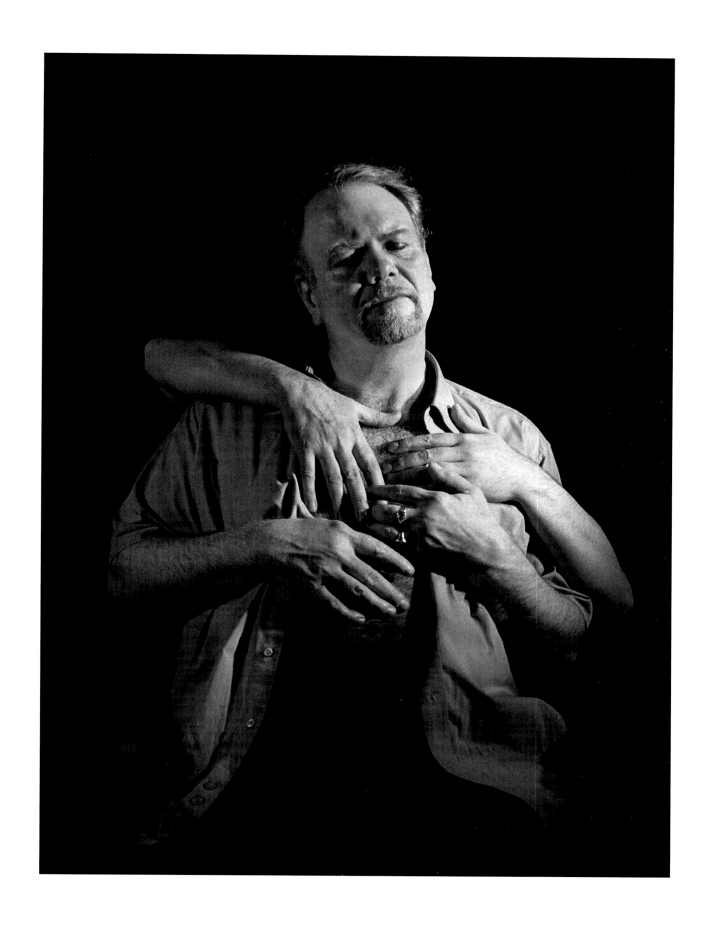

THE SOULS OF OLD MEN

In their aged, wasted bodies
dwell the souls of old men.
How pitiful the poor things are
and how weary of the wretched life they lead.
How they tremble lest they lose it and how they cherish it
these confounded and contradictory
souls—so tragicomical—that dwell
in their aged, ravaged hides.

Old men at Pamfila, Lesbos Island, 2001

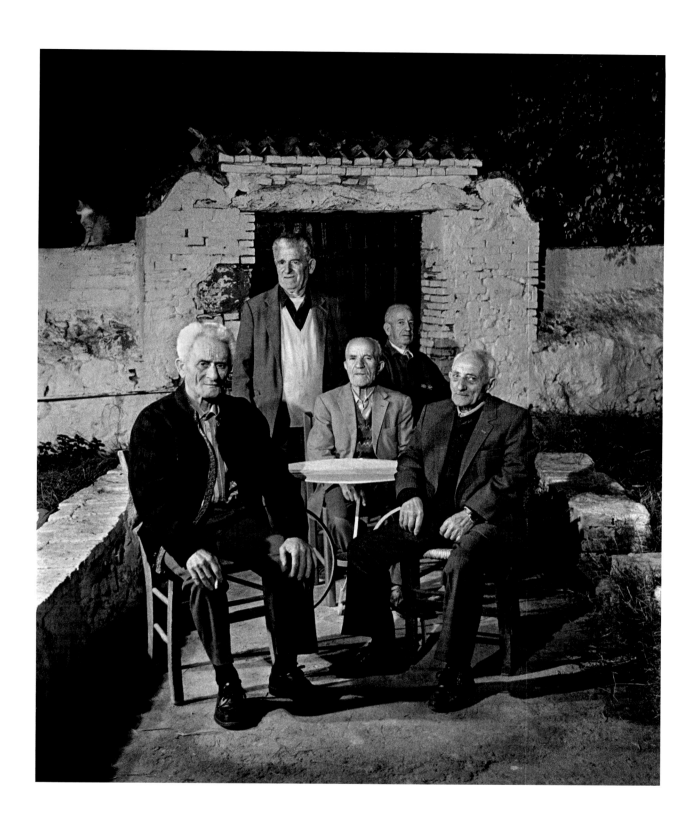

TO SENSUAL PLEASURE

Joy and balsam of my life: recollection of the hours
when I found and grasped the sensual pleasure I preferred.
Joy and balsam of my life: that I loathed
all enjoyment of commonplace loves.

David Leddick with Daron and Michael, Miami, 2001

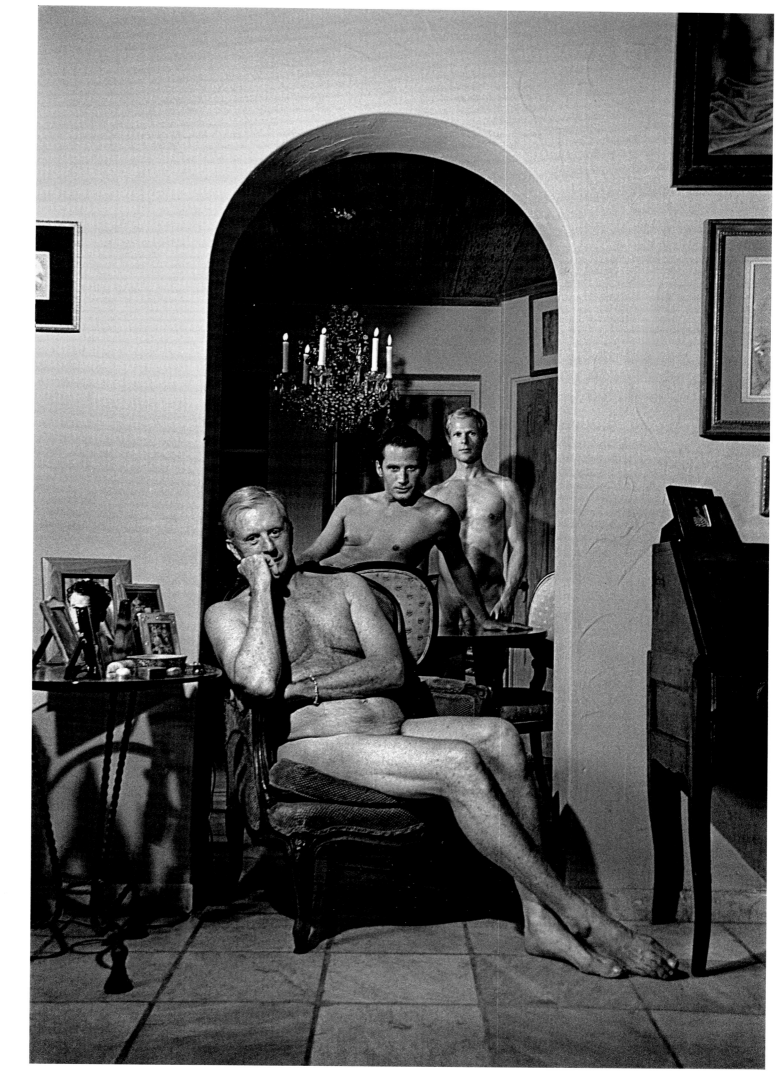

HOUSE WITH GARDEN

I wish I had a house in the country
with a huge garden—not so much
for flowers, trees, and plants
(naturally there'd be these too; they're so lovely)
but that I might have animals. O to have animals!
At least seven cats—two of them jet black
and two as white as snow, for contrast.
A splendid parrot, so I might listen to it
saying things with emphasis and conviction.
As for dogs, I think three would do me.
I'd also want two horses (ponies are nice).
And above all three or four of those remarkable
and likeable animals, donkeys,
sitting lazily, their heads contented.

Jeff Koons, New York, 2002

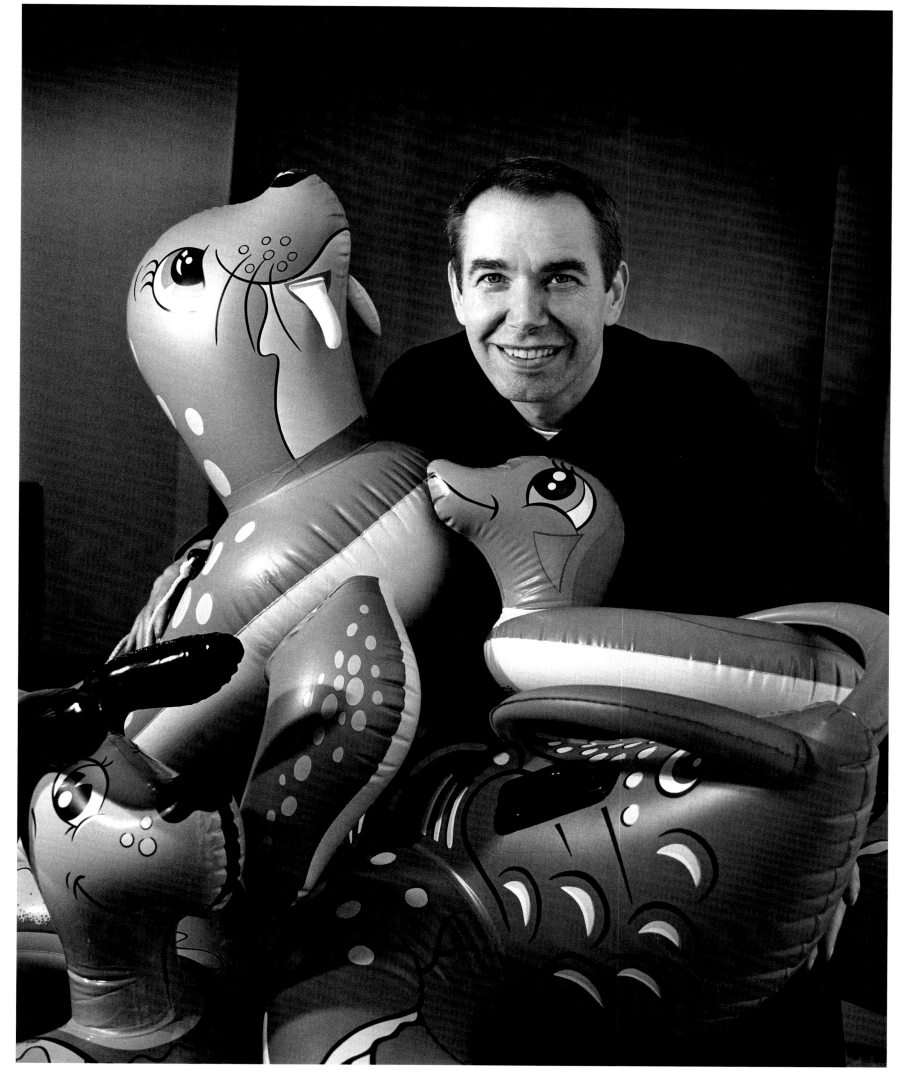

What set him apart was,
that amidst all his debauchery
and his extensive amorous experience,
despite all his customary
accord of attitude and age,
there were moments—though naturally
very rare—when he gave the impression
of virtually untouched flesh.

The beauty of his twenty-nine years,
so taxed by sensual pleasure,
at times strangely recalled
a youth who—rather awkwardly—surrenders
his chaste body to love for the first time.

Angelo, New York, 2004

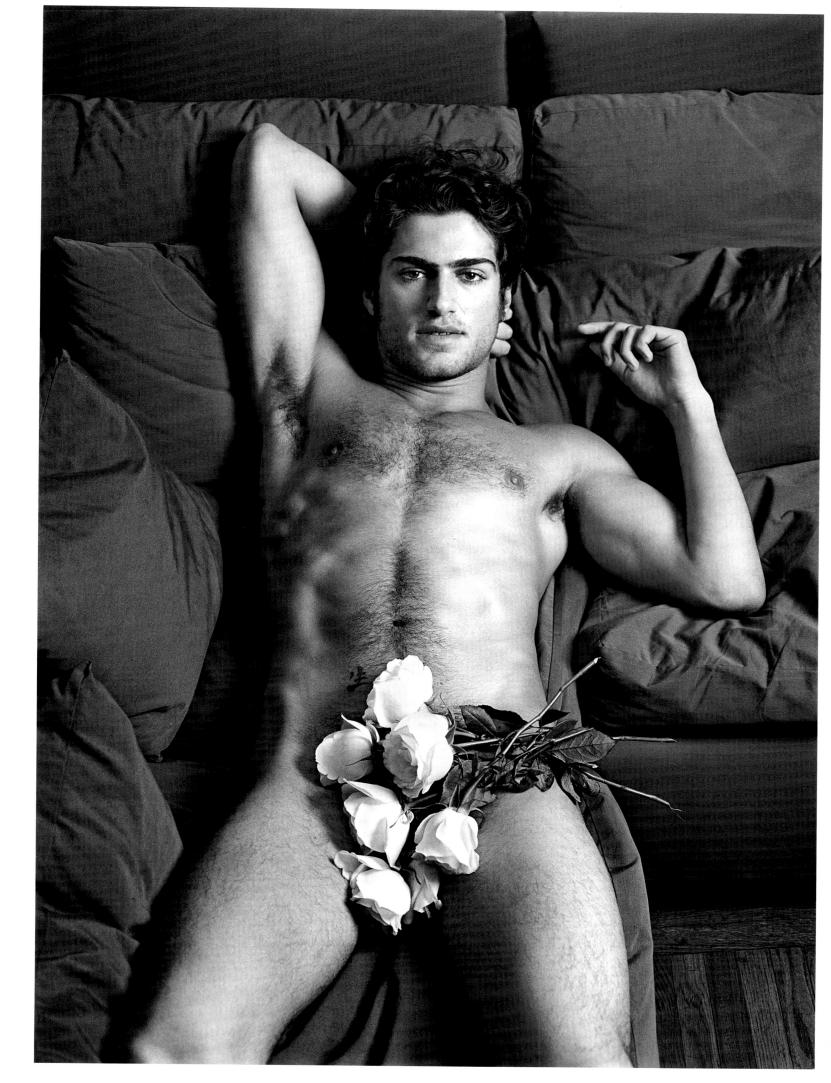

He entered the café where they used to go together.—
It was here his friend had told him three months before,
"We don't have a penny. Both of us destitute
as we are—come down to the cheapest establishments.
I'll tell you frankly, I can't go around with you
any more. Someone else, is after me, if you must know."
This someone else had promised him two suits of clothes and some
silk handkerchiefs.— To get him back
he moved heaven and earth, and came up with twenty pounds.
His friend came back to him because of the twenty pounds;
but also, apart from this, because of their old friendship,
their old love, because of their deep feelings.—
The "someone else" was a liar, a proper scoundrel;
one suit of clothes was all he'd stood him, and
this begrudgingly, after much pleading.

But now he no longer needs either the suits of clothes,
or far less the silk handkerchiefs,
or even twenty pounds or even twenty piastres.

They buried him on Sunday, at ten in the morning.
They buried him on Sunday: almost a week's gone by.

On his cheap casket he lay flowers,
lovely flowers and white as well befitted
his beauty and his two and twenty years.

When that evening he went— some business had cropped up,
vital to his livelihood— to the café where
they used to go together: like a stab in his heart
was that gloomy café where they used to go together.

Adam, New York, 2001

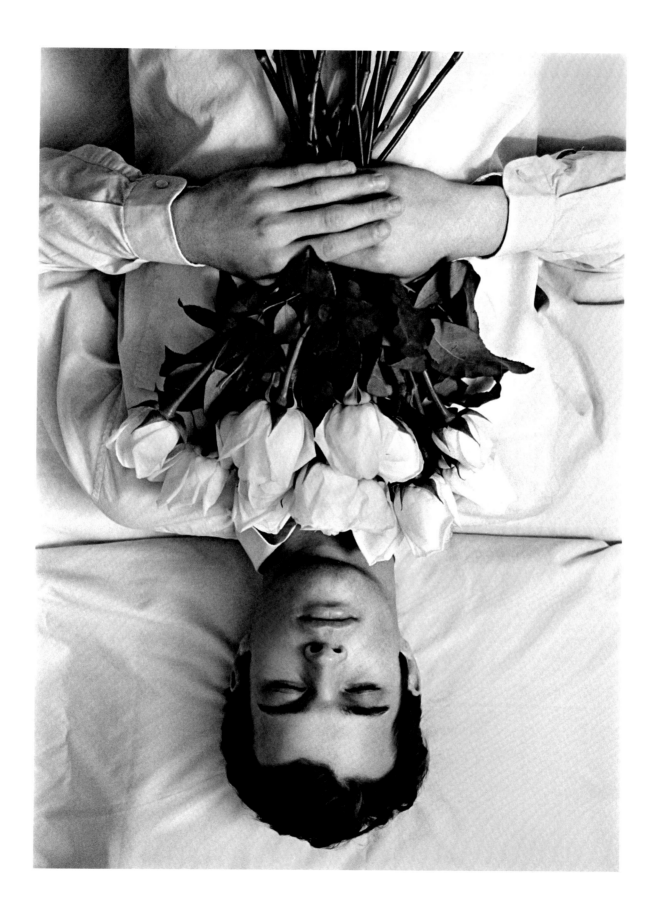

ARTIFICIAL FLOWERS

I've no love of real narcissi—nor am I fond of lilies, or real roses.
They adorn common, ordinary gardens. Their flesh fills me
with sorrow, weariness, and grief—
I tire of their perishable beauty.

Give me artificial flowers—the splendors of glaze and metal—
that never wither or rot, with looks that never age.
Flowers from exquisite gardens of another land,
where Theories, Rhythms and Knowledge dwell.

I like flowers made of glass or gold,
faithful gifts of a faithful Art;
painted in colors more fair than any natural
and wrought with nacre and enamel,
with perfect leaves and stalks.

They get their charm from sage and sound Good Taste;
they didn't sprout unclean in dirt or mud.
If they have no fragrance, we'll sprinkle scent,
burn sentiment's incense before them.

Tom Wesselmann, New York, 2002

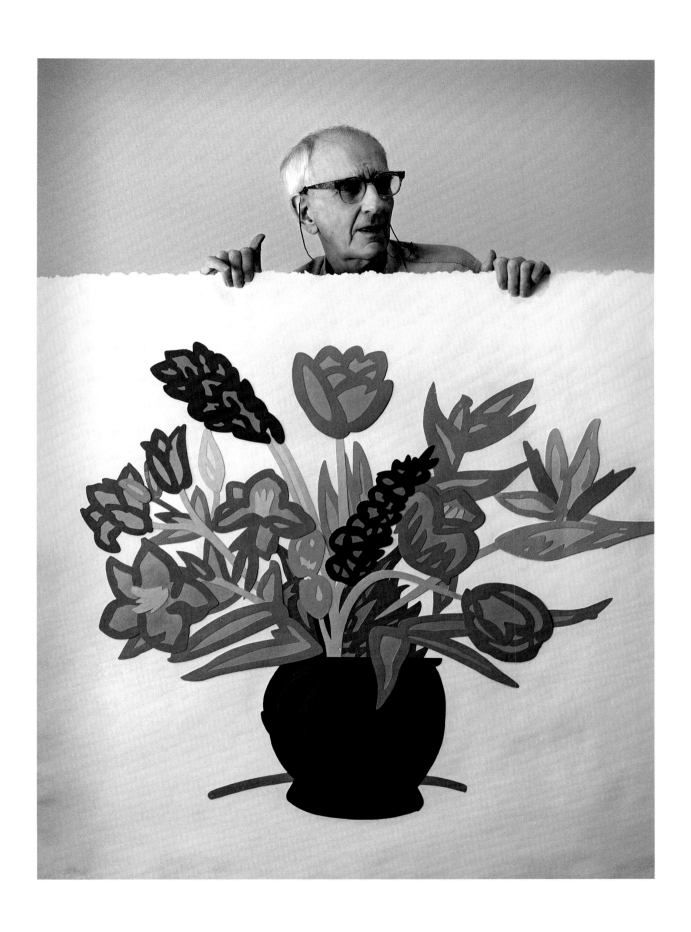

He left the office where he'd been employed
in a minor and poorly-paid position
(his monthly salary just eight pounds: with gratuities)
when he'd finished the wretched work
over which he'd pored all afternoon:
he left at seven o'clock, and walked slowly
and dawdled in the street.—Handsome;
and appealing: given that he seemed to have reached
the height of his sensual powers.
He'd turned twenty-nine the previous month.

He dawdled in the street, and in the poor
back alleys that led to where he lived.

Passing outside a small shop
which sold various goods
flimsy, cheap things for working folk,
he saw a face, a figure inside
which impelled him to enter, pretending
he wanted to see some colored handkerchiefs.

He asked about the quality of the handkerchiefs
and what they cost in a stifled voice,
almost muted by desire.
And in like manner came the answers,
vacuous, in a subdued voice,
with underlying consent.

They went on talking about the goods—but
their one concern: that their hands might touch
over the handkerchiefs; that their faces
their lips might come close, as if by chance;
a momentary contact of their limbs.

Quickly and furtively, lest they be seen
by the shop-owner sitting at the back.

Eric and Tom, New York, 2001

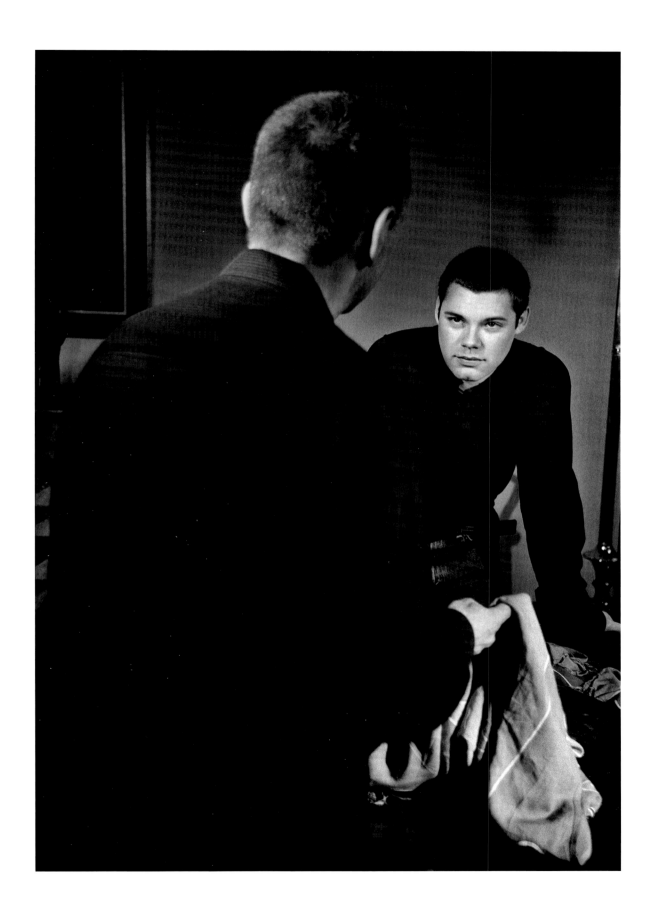

CHANDELIER

In a small bare room, four walls no more,
and draped with plain green cloth,
a lovely chandelier burns and blazes;
and in its every flame kindles
a lustful passion, a lustful urge.

In the small room that glows, lit
by the chandelier's strong fire,
by no means common is the light emitted.
Not intended for timid bodies
is this warmth's sensual delight.

Pierre and Gilles, Paris, 2002

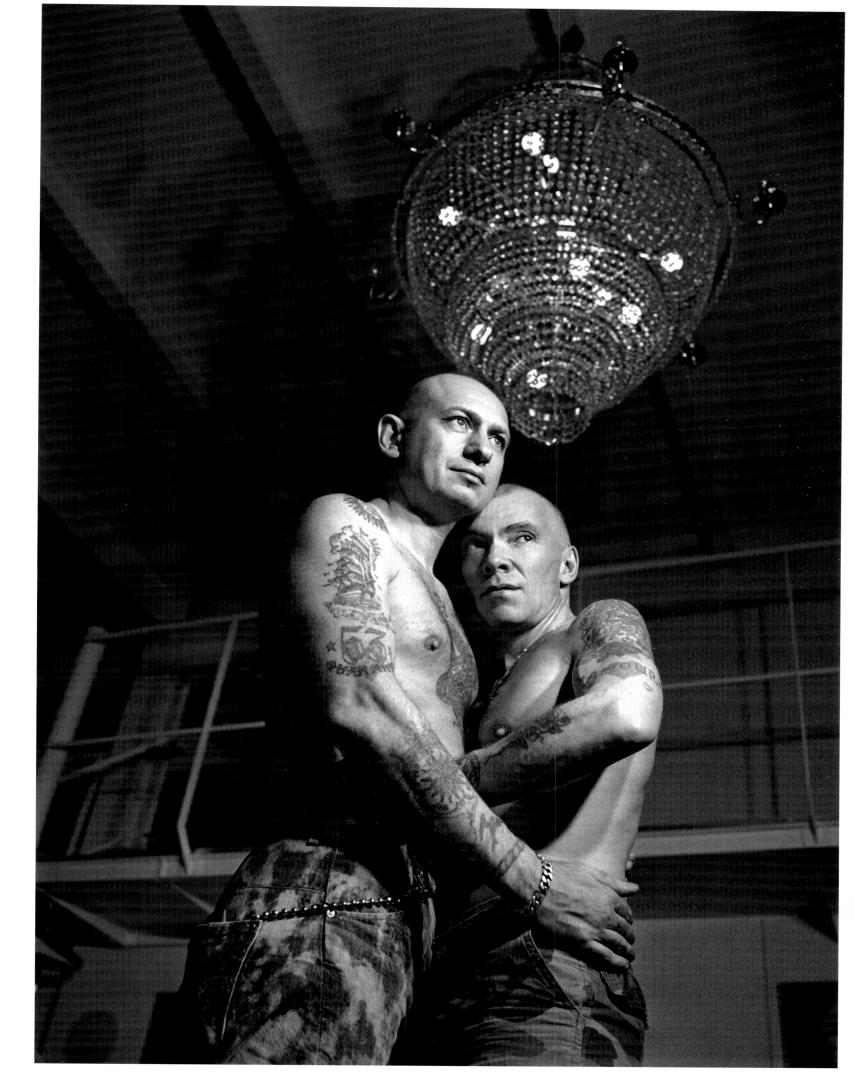

DAYS OF 1903

I never found them again—things so quickly lost . . .
the poetic eyes, the pallid
face . . . as night fell in the street . . .

I never found them again—things acquired wholly by chance,
that I so easily let go;
and afterwards agonizingly craved.
The poetic eyes, the pallid face,
those lips that I never found again.

Andrew, *New York, 2004*

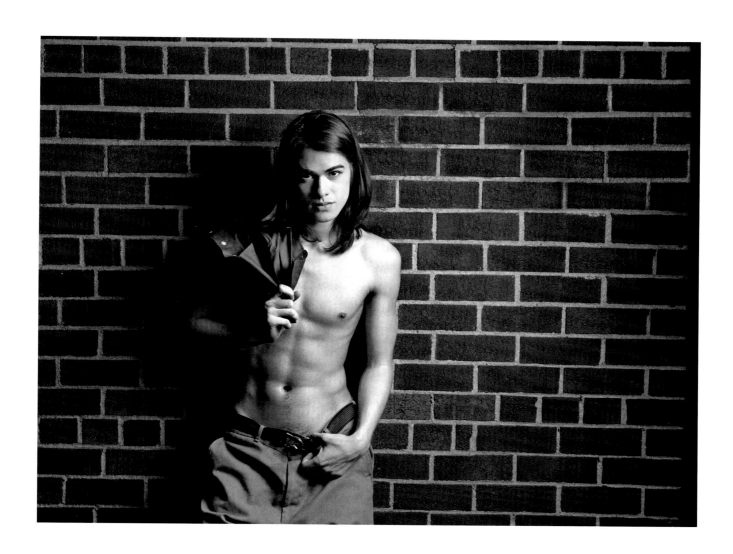

DAYS OF 1908

That year he found himself out of work;
and so was living by playing cards,
or backgammon, and by borrowing.

He'd been offered a job, in a small
stationer's, at three pounds a month.
But he turned it down, without any hesitation.
It wouldn't do. That was no salary for him,
a rather literate young man of twenty-five.

He won two or three shillings a day, if that.
What could the lad make from cards and backgammon,
in the common cafés of his kind,
however shrewdly he played, however gullible the opponents he chose.
As for the borrowing, it was neither here nor there.
He'd rarely come up with a crown, more usually only half that,
sometimes he even settled for a shilling.

For a week or so, sometimes longer,
when he got away from the awful late nights,
he'd refresh himself by bathing, by a morning swim.

His clothes were in an awful state.
He always wore the same suit, a suit
the color of very faded cinnamon.

O summer days of nineteen hundred and eight,
missing from your aspect, tastefully so,
was the faded cinnamon-colored suit.

Your aspect has preserved him as he was
whenever he removed, whenever he threw off
those unbecoming clothes, and that patched underwear.
And he remained stark naked; flawlessly beautiful; a sight to behold.
His hair uncombed, swept back;
his limbs slightly suntanned
from his morning nakedness when bathing, when on the beach.

78

Timo Schnellinger, New York, 2001

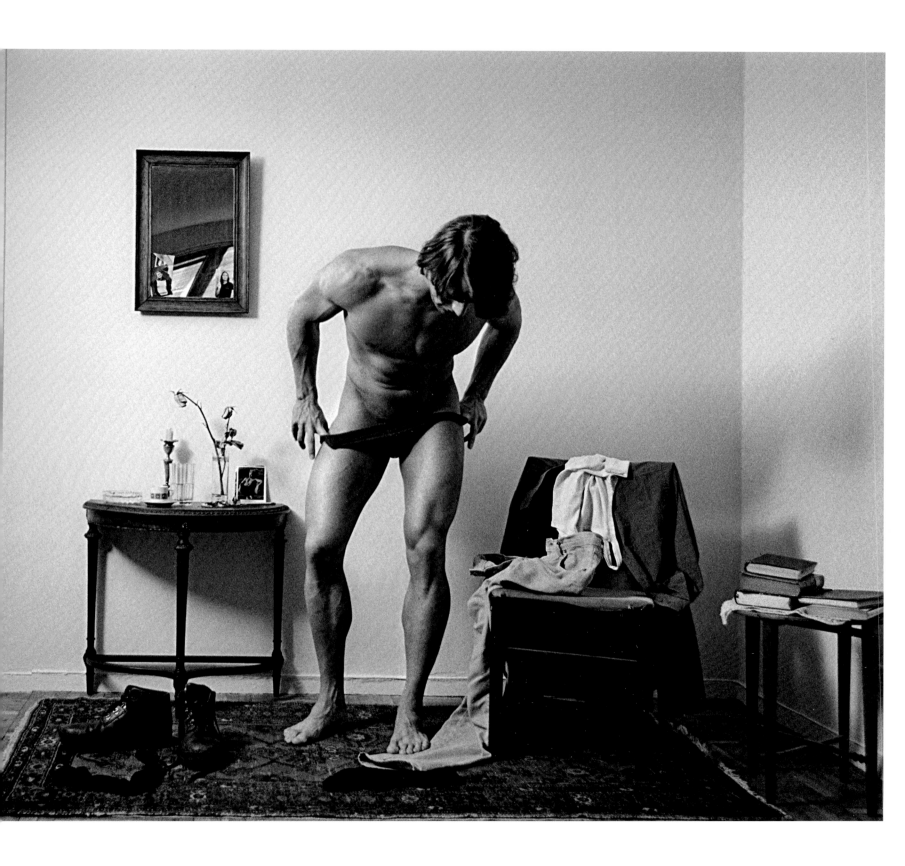

THE CAFÉ ENTRANCE

Something said beside me made me turn
my attention to the café entrance.
And I saw the beautiful body that looked
as though fashioned by Eros from his endless experience—
delightfully shaping its symmetrical limbs;
heightening the sculptured build;
shaping the face with feeling
and from the touch of his hands leaving
a sentiment on the brow, the eyes and lips.

Antonio Carmeña, New York, 2001

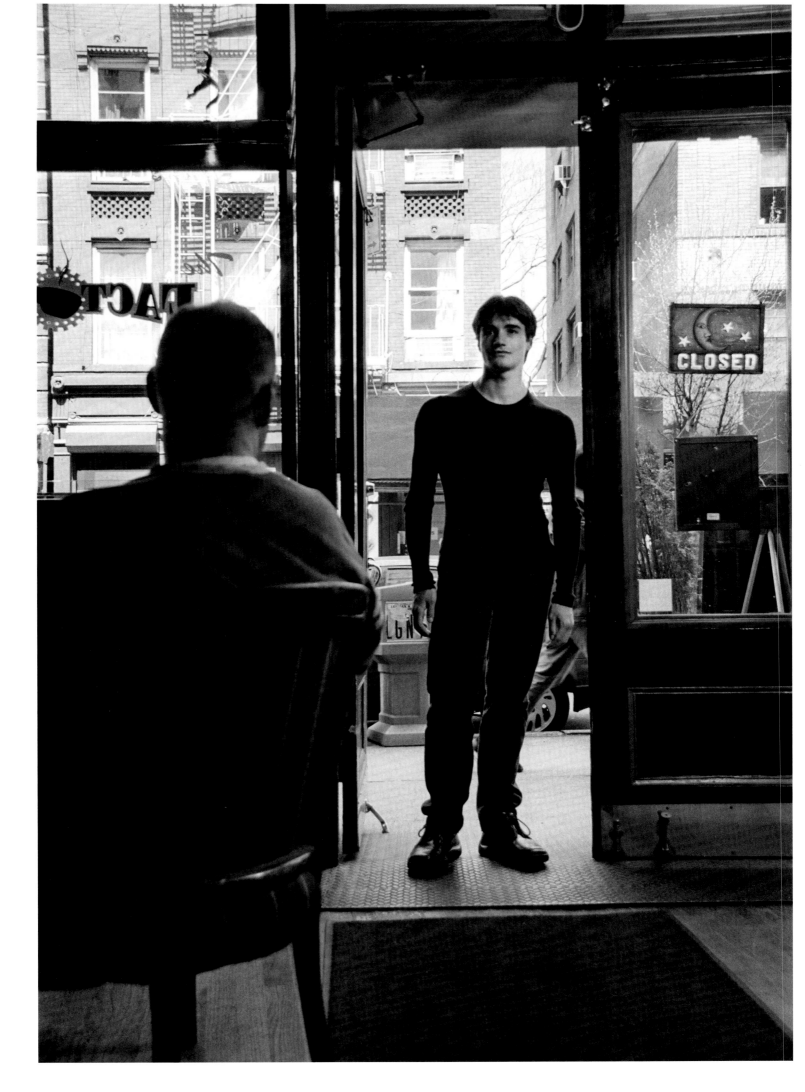

THE NEXT TABLE

He can't be more than twenty-two.
And yet I'm sure that almost as many
years ago, I enjoyed that selfsame body.

It's by no means simply a rush of desire.
And I've only just arrived at the gaming-house;
I've not had time to have too much to drink.
I enjoyed that selfsame body, I did.

And if I can't recall where—my memory lapse means little.

There, now that he's sitting at the next table
I recognize his every movement—and beneath his clothes
I can see again the naked limbs I loved.

Duane Michals and Douglas, New York, 2001

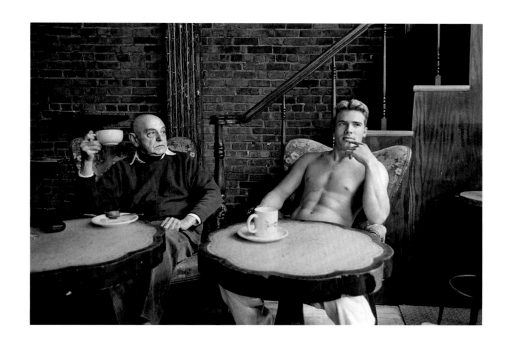

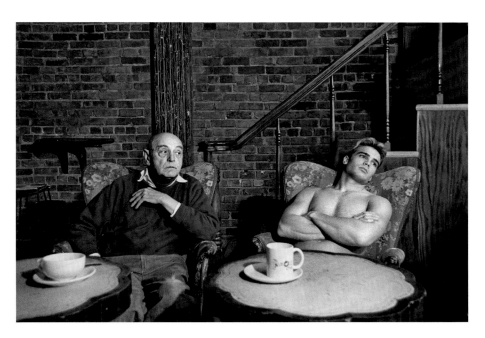

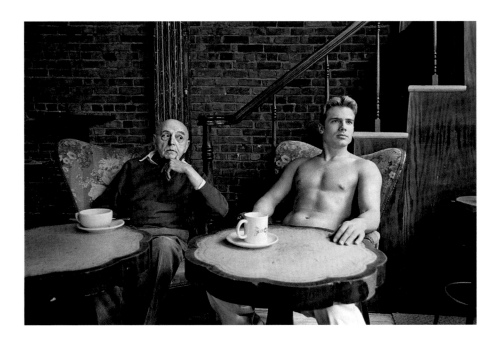

TO REMAIN

It must have been one in the morning,
or half-past one.

 In a corner of the tavern;
behind the wooden partition.
The place was completely empty save for the two of us.
An oil-lamp provided scant light.
The drowsy waiter was dozing by the door.

No one would have seen us. Yet already
we were so aroused,
that we'd become incapable of caution.

Our clothes were half-open—not that there were many
for the divine month of July was blazing hot.

Pleasure of the flesh through
the half-open clothes;
quick baring of the flesh—the image of which
crossed twenty-six years; and has come now
to remain in this poetry.

Leonardo and Rodolfo, Mexico City, 2004

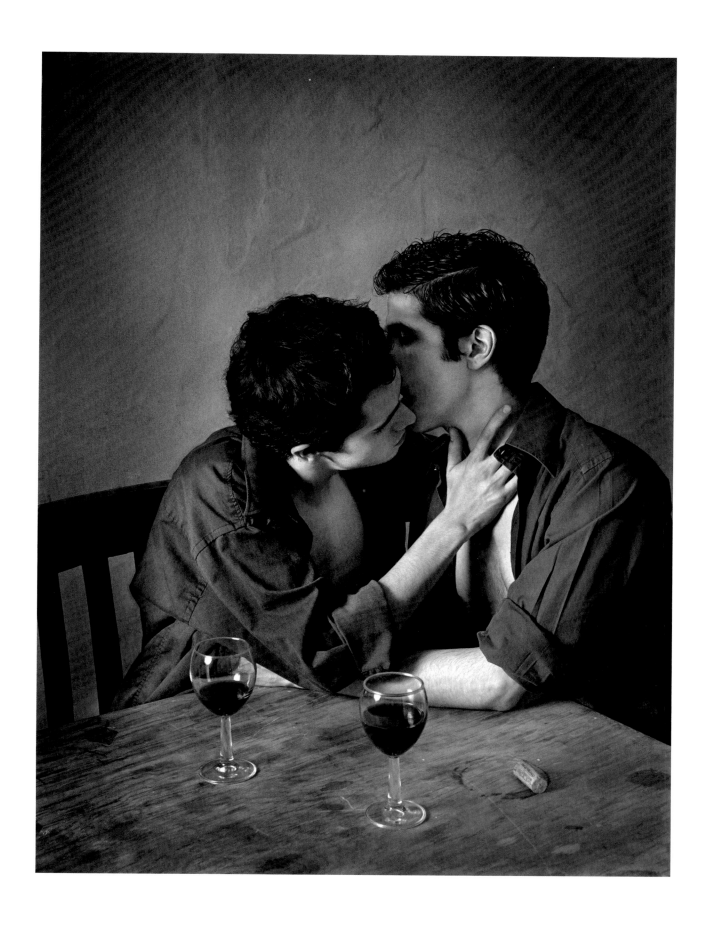

ON THE STAIRS

As I was going down the shameful staircase,
you were coming through the door, and momentarily
I saw your unfamiliar face and you saw me.
Then I turned away so you wouldn't see me again and you
hurried past turning away your face,
and darted inside the shameful house
where you wouldn't find pleasure, as I hadn't found it.

And yet the love that you wanted I had to give you;
the love that I wanted—your eyes told me
your tired and furtive eyes—you had to give me.
Our bodies sensed and sought each other;
our blood and skin understood.

But we both turned away in alarm.

Self-portrait with Costas, Lesbos Island, 2001

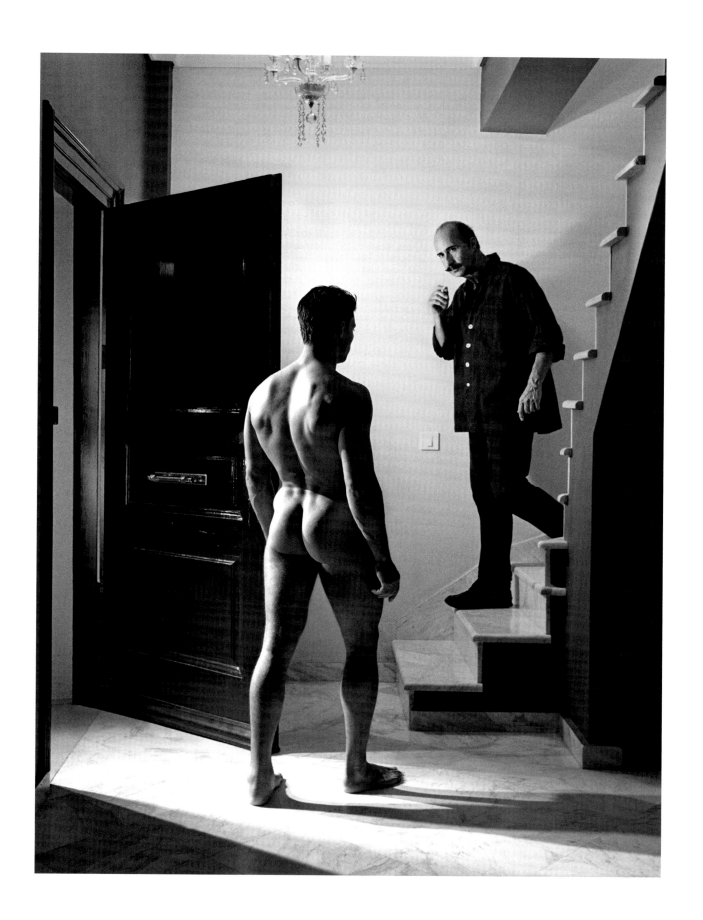

THEIR BEGINNING

The fulfillment of their illicit passion
was complete. Getting up from the mattress,
they hastily dress without saying a word.
They leave the house separately, secretly; and
walk rather nervously down the street, as if
they suspect that something about them betrays
the kind of bed they shared just now.

Yet how the artist's life has gained.
Tomorrow, the day after, or years later he'll compose
the powerful verses that had their beginning here.

Angelo and Mad, New York, 2002

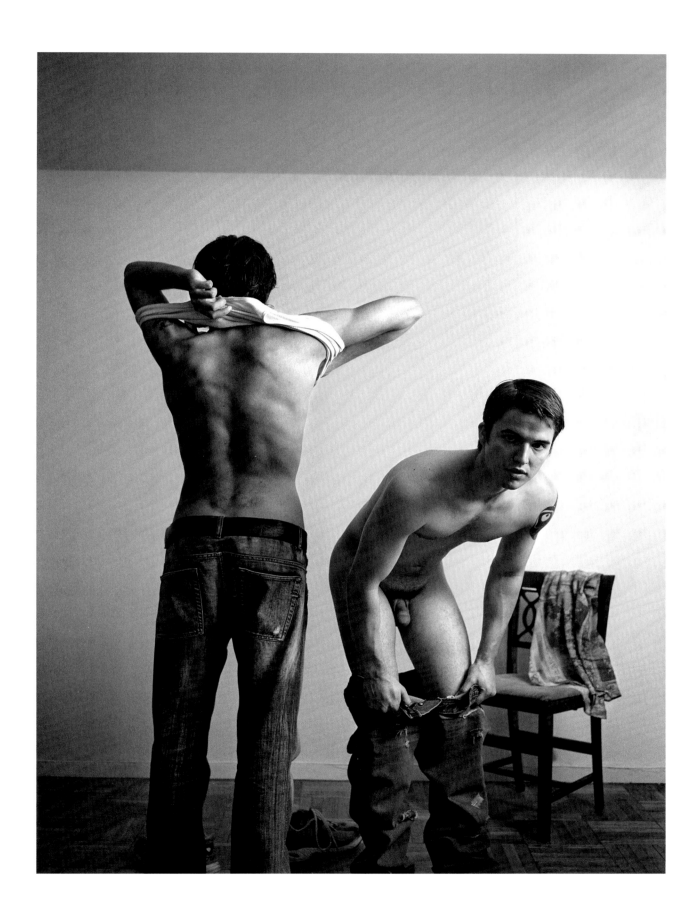

He was utterly disgraced. A sexual inclination of his
strictly forbidden and scorned
(innate nonetheless) was the reason:
society was exceedingly prudish.
He gradually lost what little money he had;
then his standing, and his good name.
He was nearly thirty without ever a whole year
spent in work at least not any recognized kind.
Sometimes he earned his living from
mediations that were deemed shameful.
He ended up the type with whom if seen
too often, no doubt you'd be seriously compromised.

But this isn't everything. It wouldn't be fair.
The memory of his beauty is deserving of much more.
For there's another side and if seen from this
he appears an amiable sort; he appears a simple and genuine
child of love, who above honor
and good name unquestioningly placed
the pure pleasure of his pure flesh.

Above his good name? For society which was
exceedingly prudish made foolish connections.

Zachary, New York, 2002

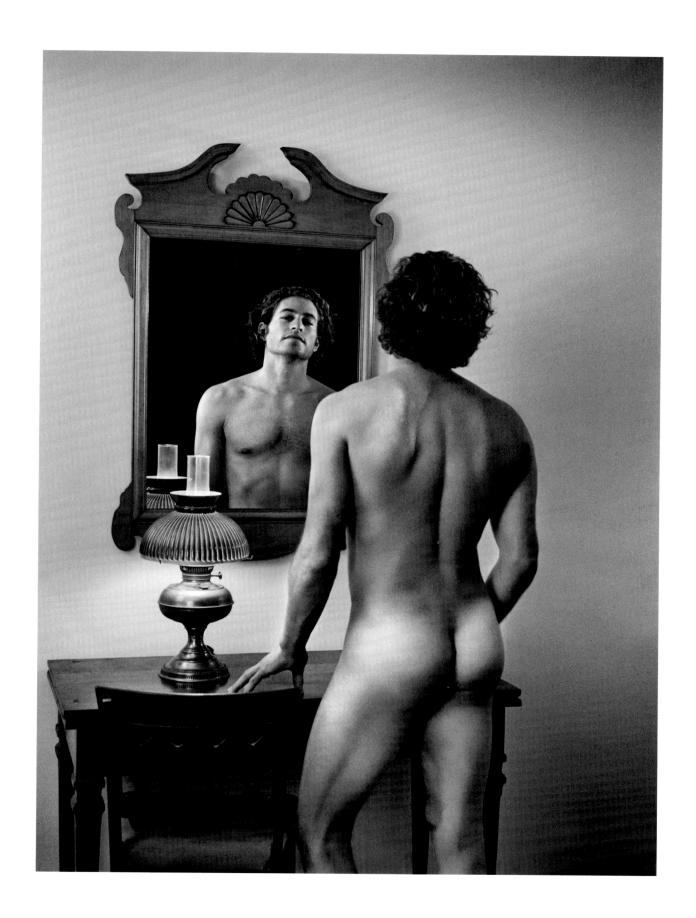

I showed no restraint. I gave in completely and went.
To the delights, that were half real,
half wheeling in my mind,
I went in the luminous night.
And I drank of heady wines, just
as sensuality's stalwarts drink.

Clive Barker and David Armstrong, Los Angeles, 2005

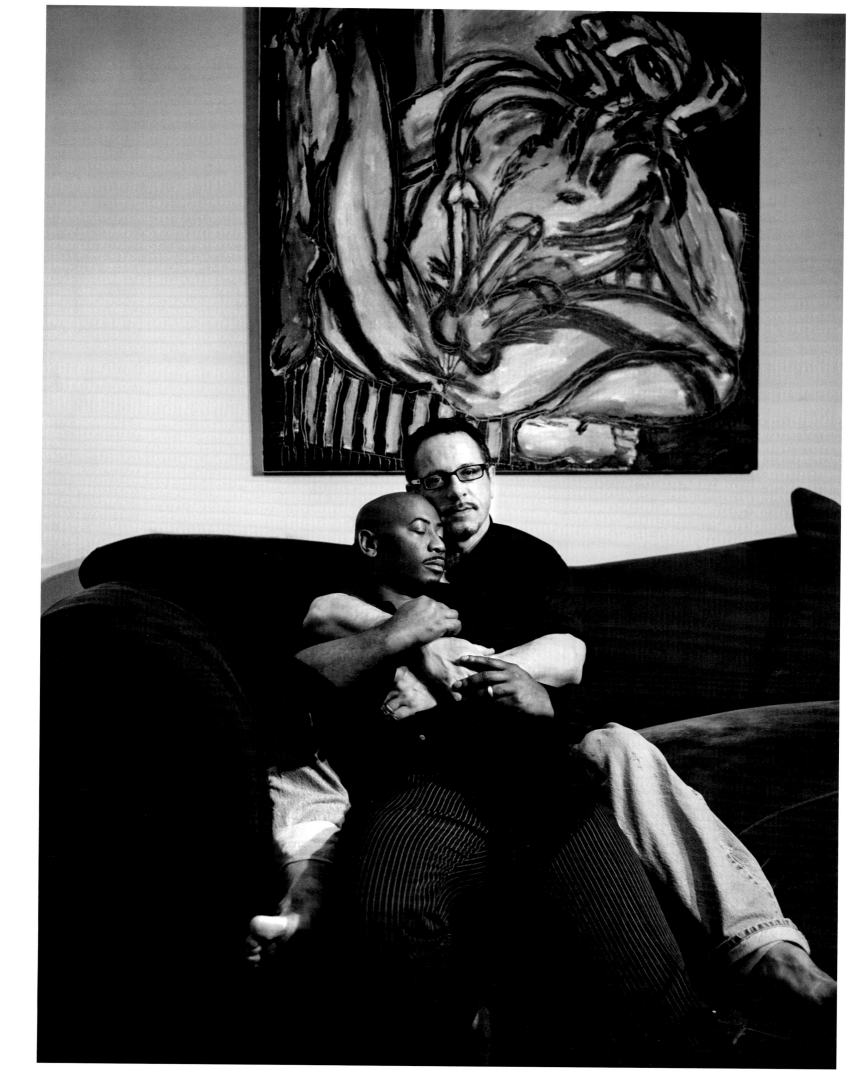

ON HEARING OF LOVE

On hearing of overpowering love tremble and be moved
like an aesthete. But, content,
recall all your imagination fashioned for you; these things
first; and then the rest—lesser things—that in your life
you experienced and enjoyed, things more real and tangible.—
Of such loves you were not deprived.

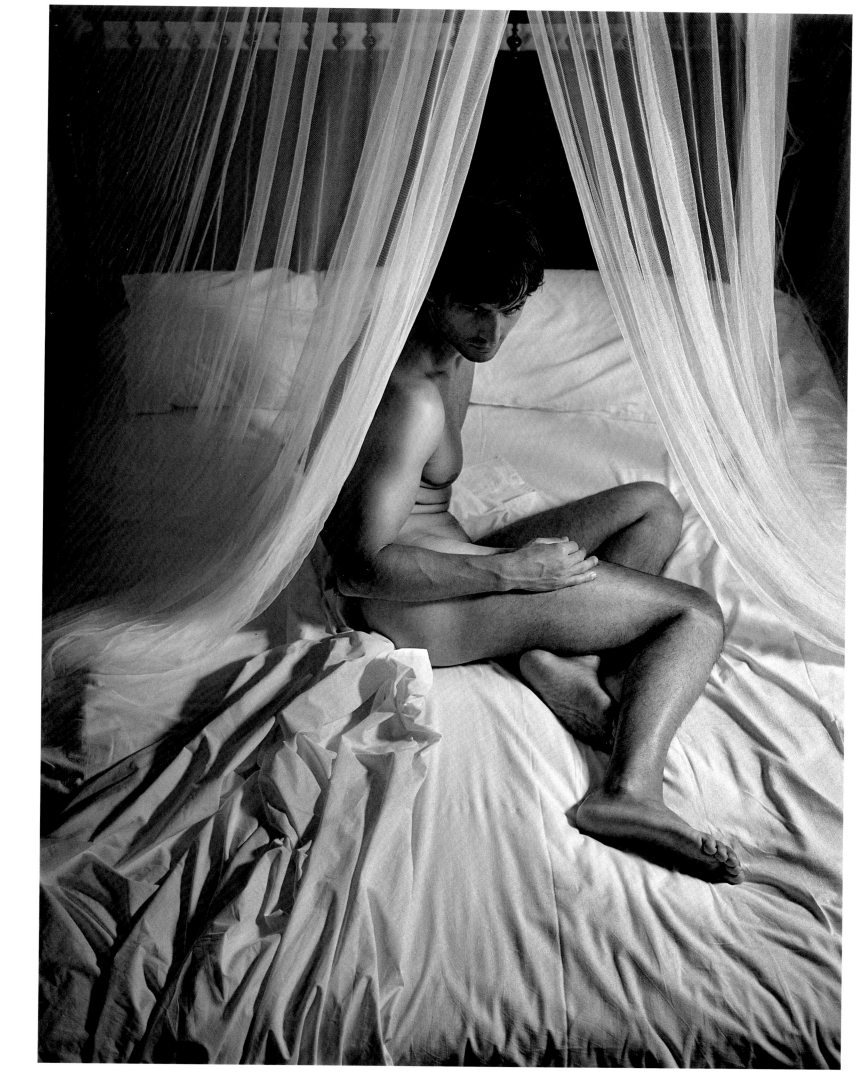

CAESARION

Partly to check up on a period,
partly also to pass the time,
last night I chose to read a collection
of inscriptions pertaining to the Ptolemies.
The lavish praise and flattery
are much the same for all of them. All are illustrious,
celebrated, mighty, beneficent;
their every undertaking the most astute.
As for the women of the line, they too,
the Berenices and Cleopatras, are all wonderful.

When I'd successfully checked up on the period
I would have put the book down had not a reference,
a small and insignificant one, to King Caesarion
instantly caught my attention . . .

There, then, you came with your indefinable
charm. History reserves
but a few lines for you,
and so I fashioned you more freely in my mind.
I made you fair and sensitive.
My art lends to your face
a dreamlike, engaging beauty.
And so fully did I imagine you,
that late last night, as my lamp
went out—I deliberately let it go out—
I fancied that you entered my room,
it seemed you stood before me; as you must have been
in conquered Alexandria,
pale and weary, ideal in your sorrow,
still hoping you would be shown mercy
by the villains—who murmured "Too many Caesars".

Christopher, New York, 2004

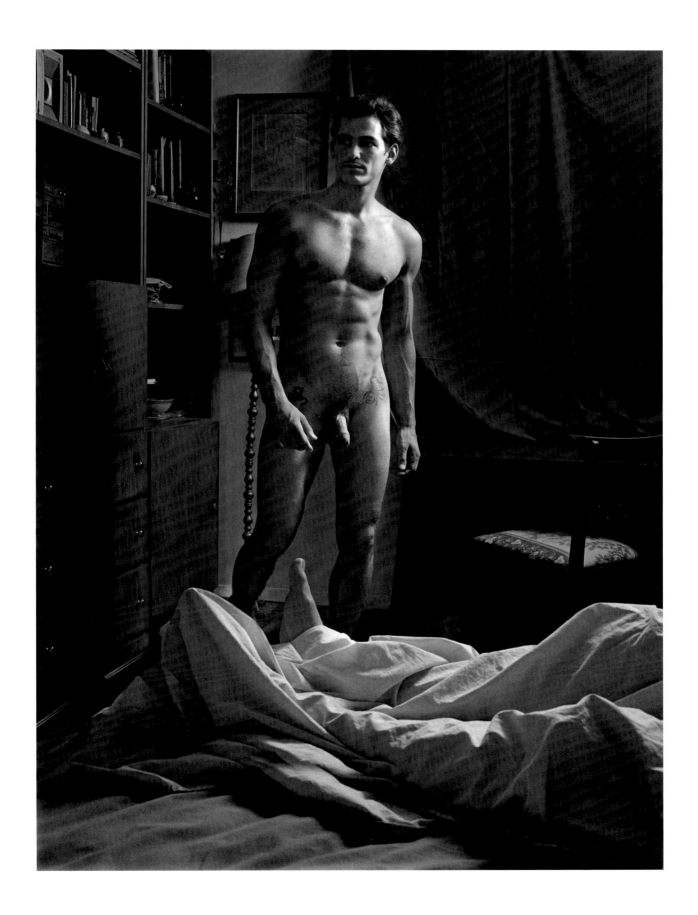

He came to read. Still open are
two or three books; historians and poets.
But he read for barely ten minutes,
and put them aside. He's dozing
on the sofa. Books are his whole life—
but he's twenty-three, and exceedingly handsome;
and this afternoon desire passed
into his perfect flesh, his lips.
Into his flesh which is sheer beauty
desire's glow passed;
with no foolish shame for the kind of pleasure . . .

Teo, Athens, 2009

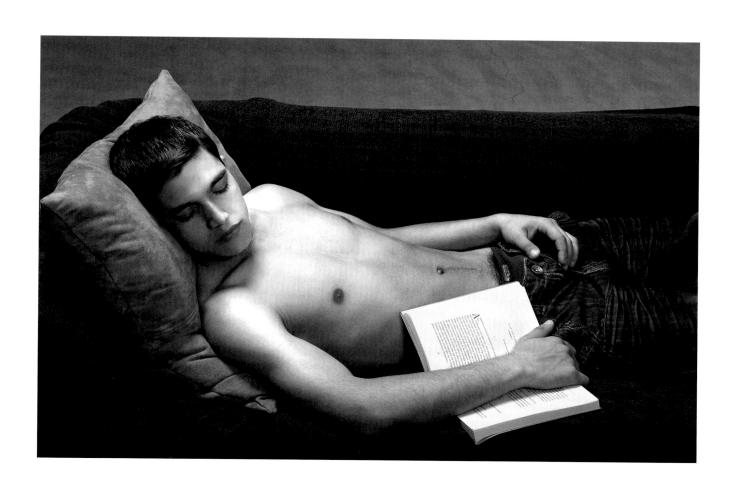

THE MIRROR IN THE ENTRANCE

In its entrance the lavish house had
a huge mirror, extremely old;
bought all of eighty years before.

A most comely lad, a tailor's assistant
(and an amateur athlete on Sundays),
stood there with a package. He handed it
to a member of the household, who took it inside
to fetch the receipt. The tailor's assistant
remained alone and waited.
He went up to the mirror and regarding himself
straightened his tie. Five minutes later
they brought him the receipt. He took it and left.

But the old mirror that in its long lifetime
had seen oh had seen
thousands of objects and faces;
this same old mirror now rejoiced,
and gloried in having for a few minutes
held to itself that consummate beauty.

Issa, Lesbos Island, 2009

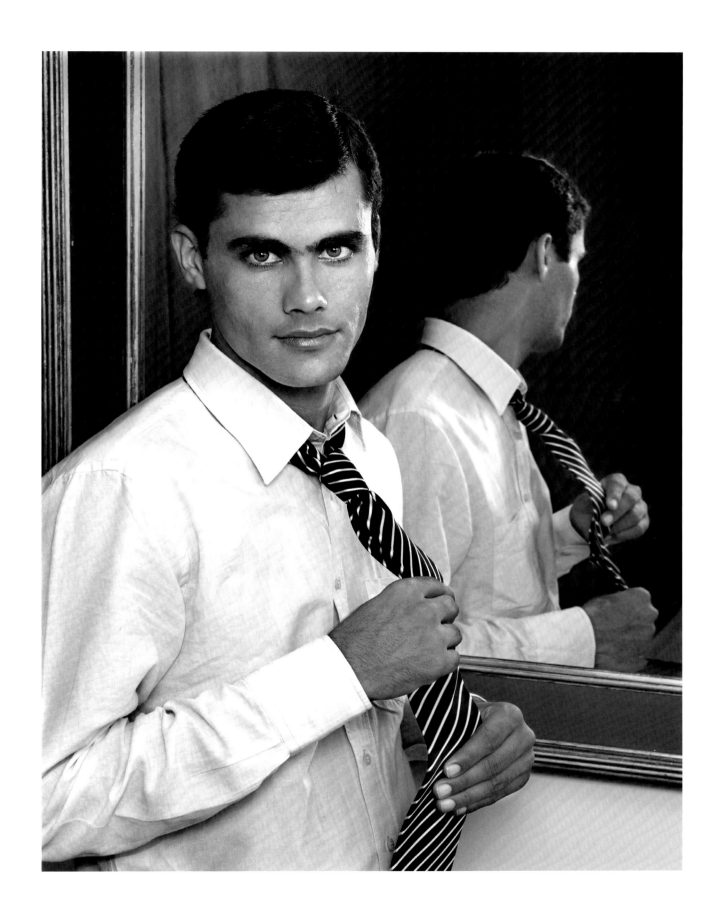

IN THE STREET

His comely face, slightly pale;
his chestnut eyes, somewhat heavy;
twenty-five years' old, but he looks more like twenty;
with something arty about his dress
—the color of his tie, the cut of his collar—
he walks aimlessly in the street,
as though still entranced by the illicit pleasure,
the so very illicit pleasure that had been his.

Dionisios, New York, 2002

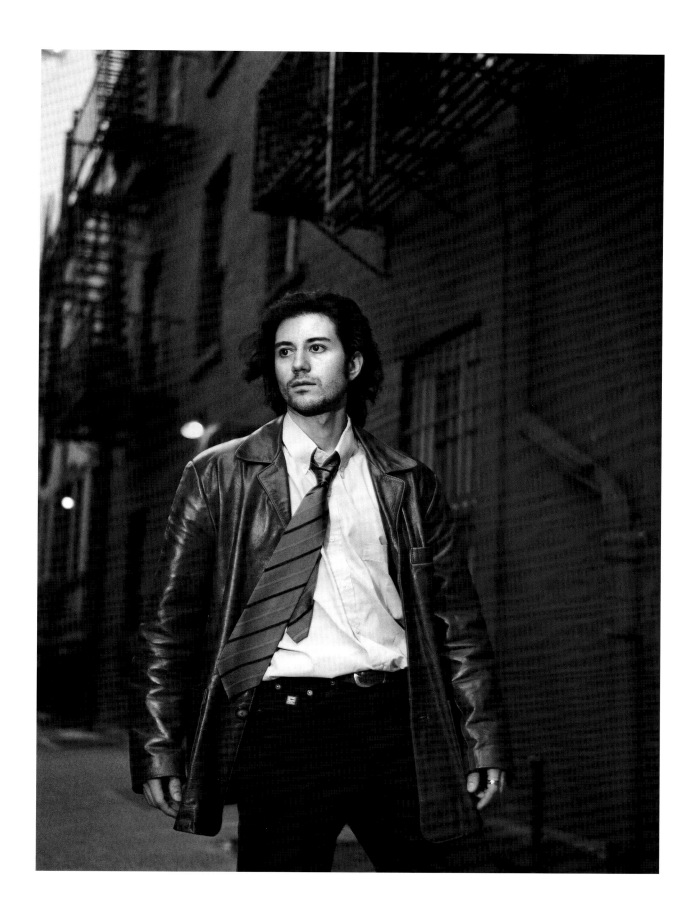

IN THE SAME PLACE

Home, clubs, neighborhood, these surroundings
that I see and where I walk; year in year out.

I created you amid joy and sorrows:
out of so many events, so many things.

And for me you've become wholly feeling.

Carlos Fuentes, Mexico City, 2008

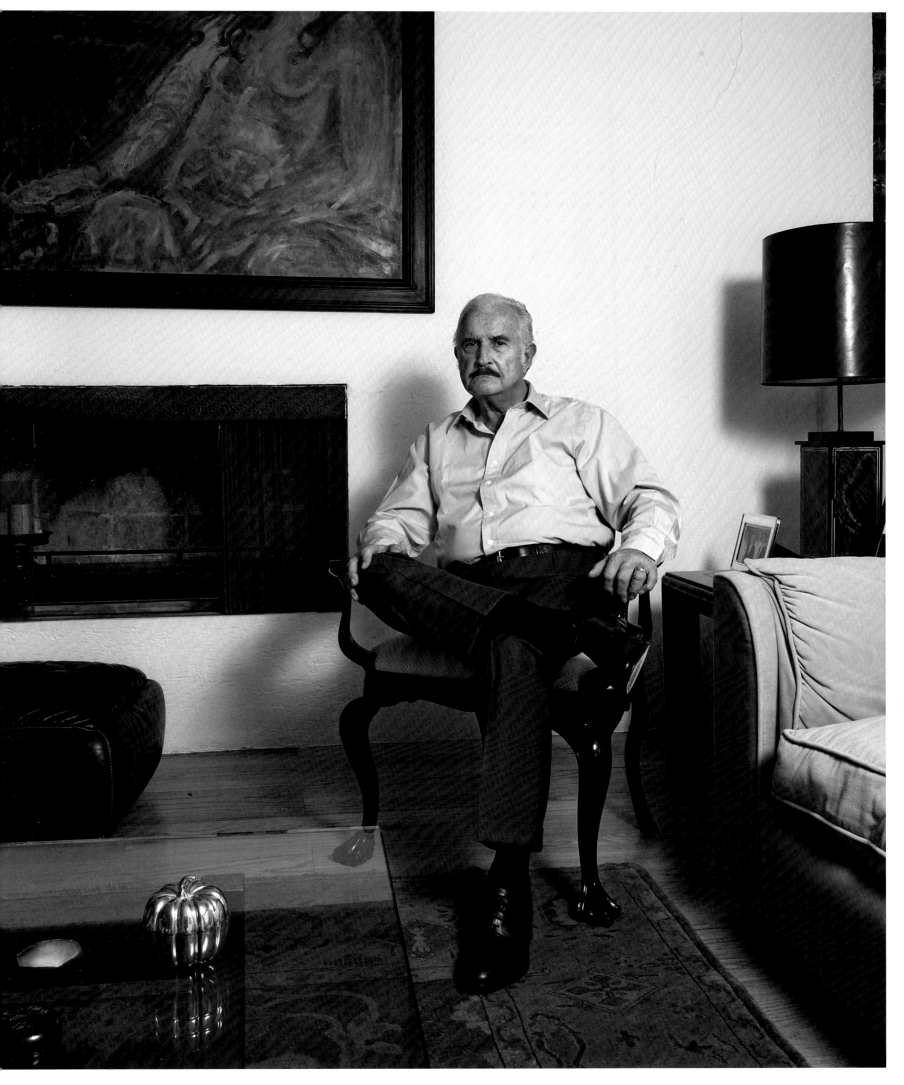

IN DESPAIR

He lost him completely. And now
in the lips of each new lover
he seeks his lips; in the union with each
new lover he seeks to deceive himself
that it's the same young man, that he's surrendering to him.

He lost him completely, as if he'd never existed.
For the young man wanted—he said— wanted to save himself
from that tainted, unwholesome pleasure;
from that tainted, shameful pleasure.
There was still time— so he said—to save himself.

He lost him completely, as if he'd never existed.
Through imagination, through fantasies
in the lips of other young men he seeks his lips;
trying to feel his sensual love once more.

François and Diego Centeño, Athens, 2005

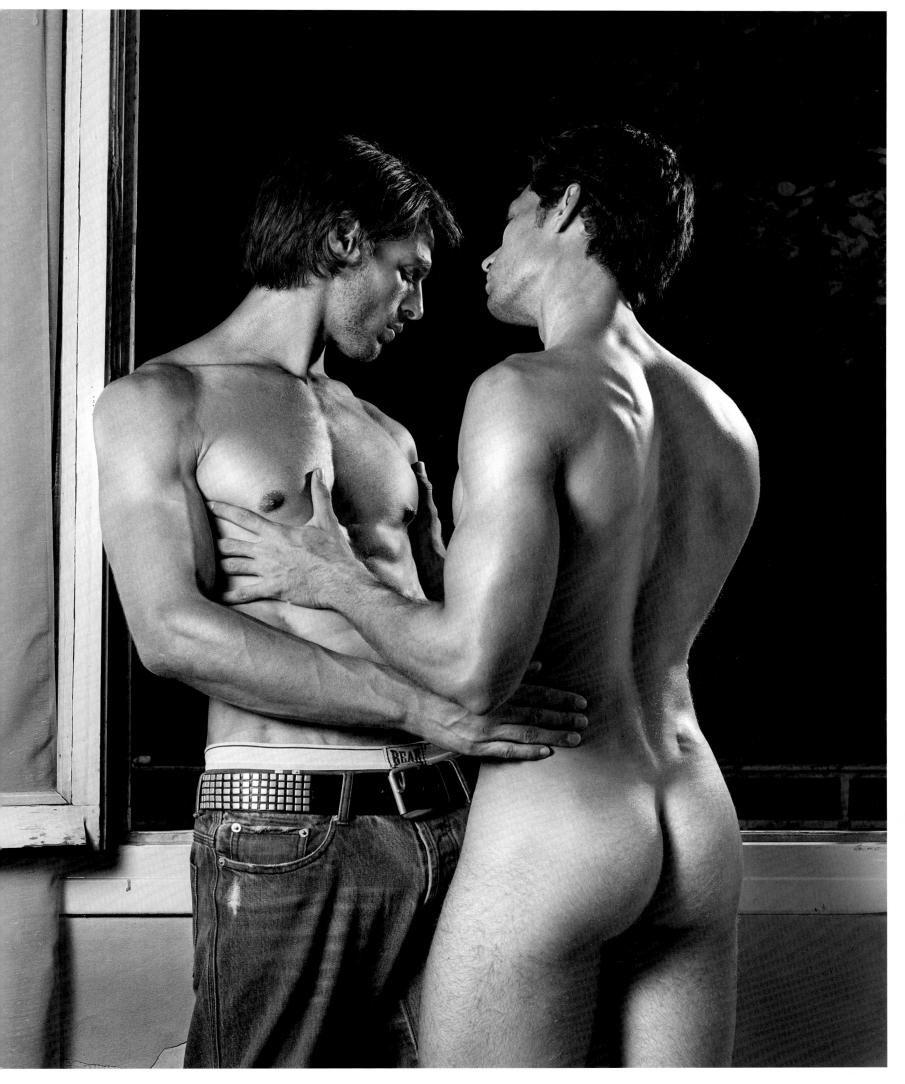

AND I SAT AND RECLINED ON THEIR BEDS

When I entered pleasure's house,
I left the room where with propriety
sanctioned loves celebrate.

I went into the secret chambers
and I sat and reclined on their beds.

I went into the secret chambers
thought shameful even to mention
But not shameful to me—for then
what kind of poet or artist would I be?
Better to be a hermit. It would be more in accord
much more in accord with my poetry;
than for me to find joy in that commonplace room.

Edward Lucie-Smith with Photis and Nicos, Athens, 2007

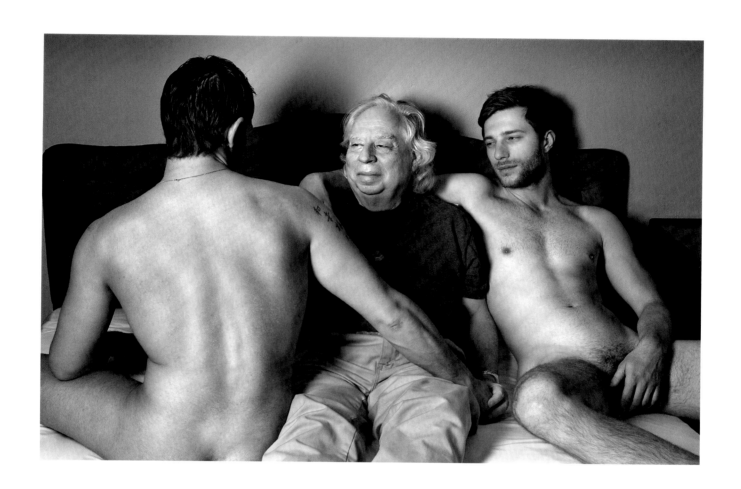

PORTRAIT OF A TWENTY-THREE-YEAR-OLD
PAINTED BY HIS FRIEND OF SIMILAR AGE, AN AMATEUR

He finished the portrait yesterday afternoon. Now
he's examining it in detail. He painted him in a grey
unbuttoned jacket, deep grey; without
vest or tie. With a rose-colored
shirt; slightly open, to show something
of the beauty of his chest and neck.
The right side of his brow is almost all
covered by his hair, his lovely hair
(in the style he prefers this year).
There's that tone that wholly sensual tone
that he wanted to impart when he did the eyes,
when he did the lips . . . His mouth, lips
made for the fulfillment of a choice passion.

Diego Centeño, Athens 2005

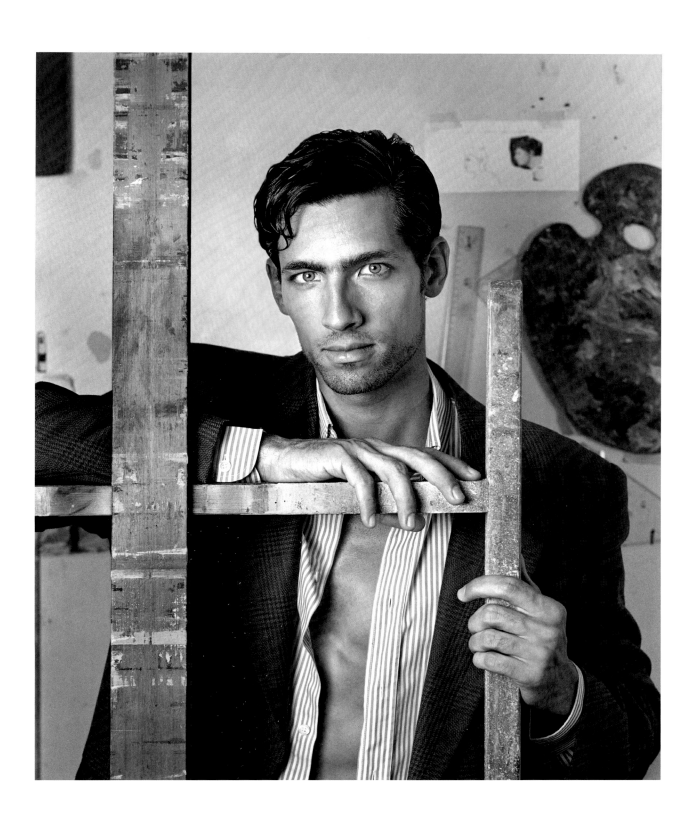

BEFORE TIME CHANGES THEM

They were hugely saddened at their parting.
It wasn't what they wanted; it was circumstances.
The need to make a living forced one of them
to leave for distant parts— New York or Canada.
Of course their love wasn't the same as before;
the attraction had gradually diminished,
the attraction had considerably diminished.
But separation wasn't what they wanted.
It was circumstances.— Or perhaps Fate
showed itself an artist separating them now
before their feeling fades, before Time changes them;
for each of them the other will always remain
a handsome youth of twenty-four.

Charles, New York, 2002

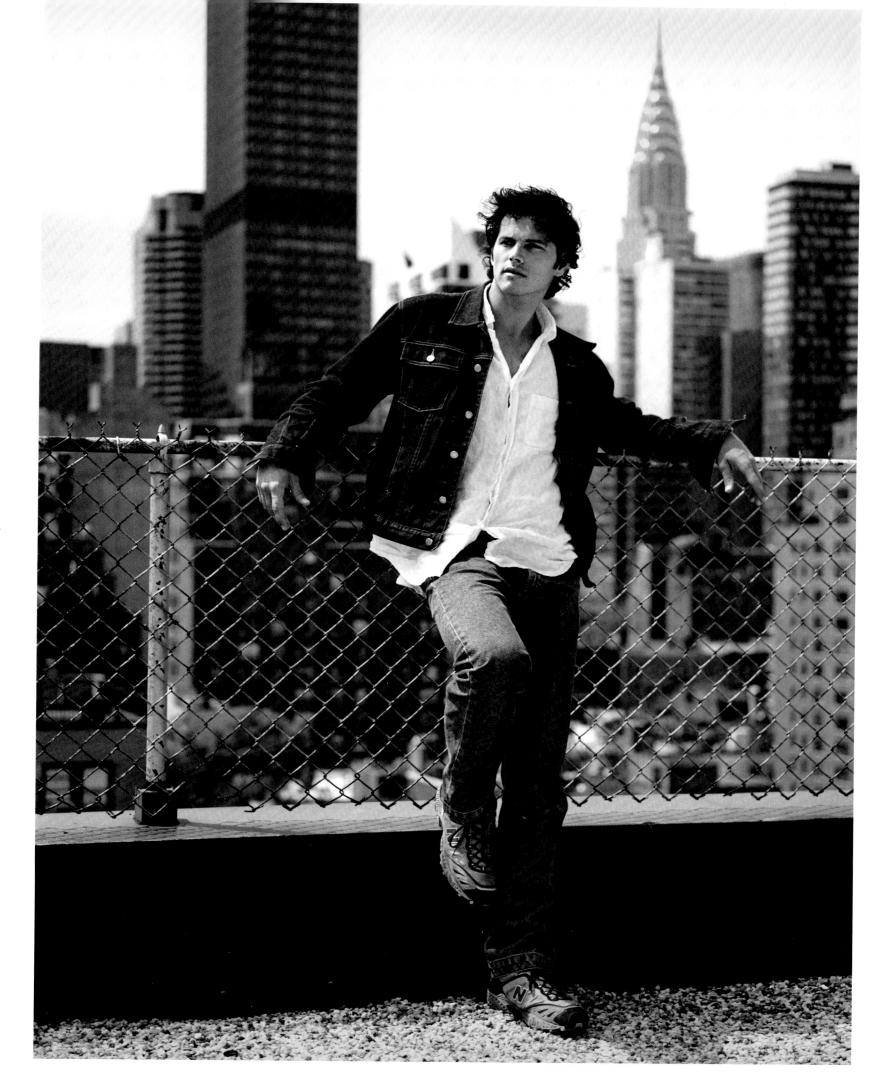

SOPHIST LEAVING SYRIA

Distinguished sophist since you're leaving Syria
and intending to write about Antioch,
you should mention Mebes in your work.
Renowned Mebes who is unquestionably
the comeliest youth and the most beloved
in all Antioch. No other youth
living like that is paid
as handsomely as he. To have Mebes with them
for just two or three days they very often give him
as much as a hundred staters.— In Antioch, I said;
but in Alexandria too, and even in Rome,
there is no youth as desirable as Mebes.

John, Lesbos Island, 2002

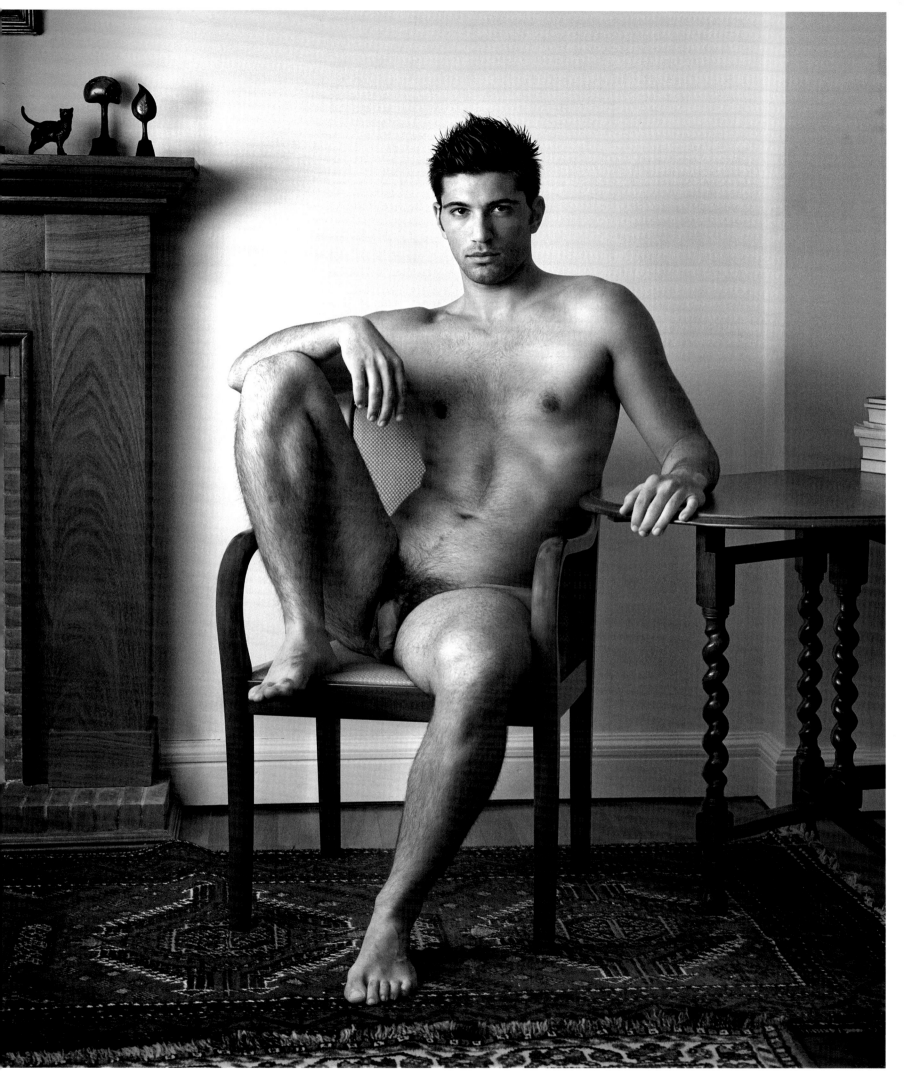

I'VE LOOKED SO MUCH—

I've looked so much upon beauty
that my vision is replete with it.

The body's contours. Red lips. Sensual limbs.
Hair as though taken from Greek statues;
always lovely, even when disheveled,
and falling, slightly, over white brows.
Faces of love, just as my poetry
wanted them . . . in the nights of my youth,
in those nights of mine, secretly encountered . . .

Brad, Garret, and Sean, New York, 2001

SUPPLICATION

The sea took a sailor to its depths.—
Unaware, his mother goes and lights

a long candle to the Holy Virgin
for his swift return and for fair weather—

and always she has her ear to the wind.
But while she prays and supplicates,

the icon listens, grave and sorrowful,
knowing the son she awaits is not coming back.

Olympia Dukakis, Athens, 2010

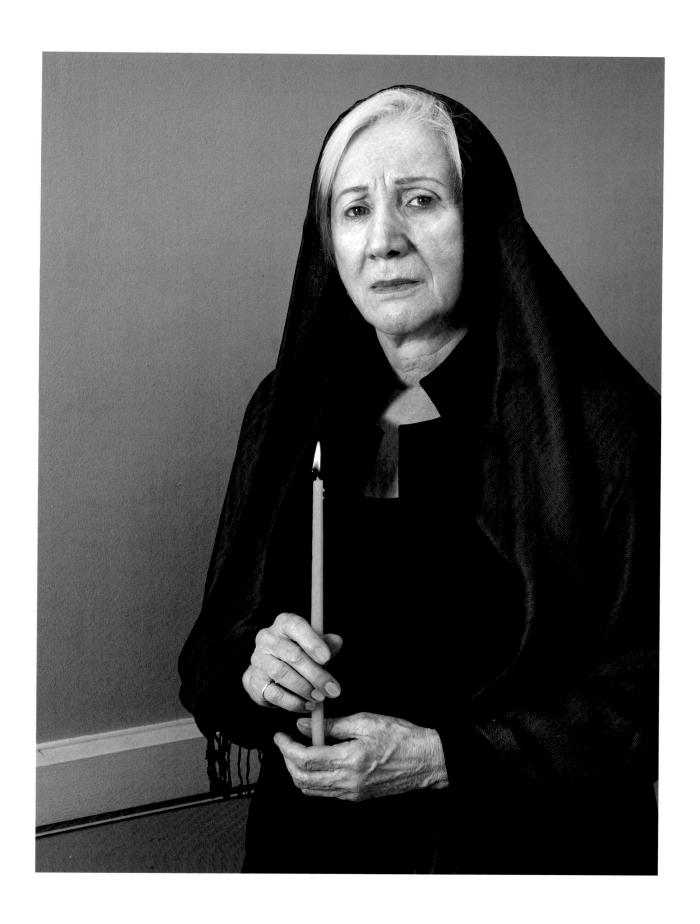

On gazing at a part grey opal
I recalled two beautiful grey eyes
I'd seen; it must be twenty years ago . . .
.
We were lovers for a month.
Then he went away, to Smyrna I believe,
to work, and we never met again.

The grey eyes—if he's alive—will have dulled;
the fair face will have wrinkled.

Memory, preserve them as they were.
And, memory, whatever you can of this love of mine,
whatever you can bring back to me tonight.

Levi, New York, 2006

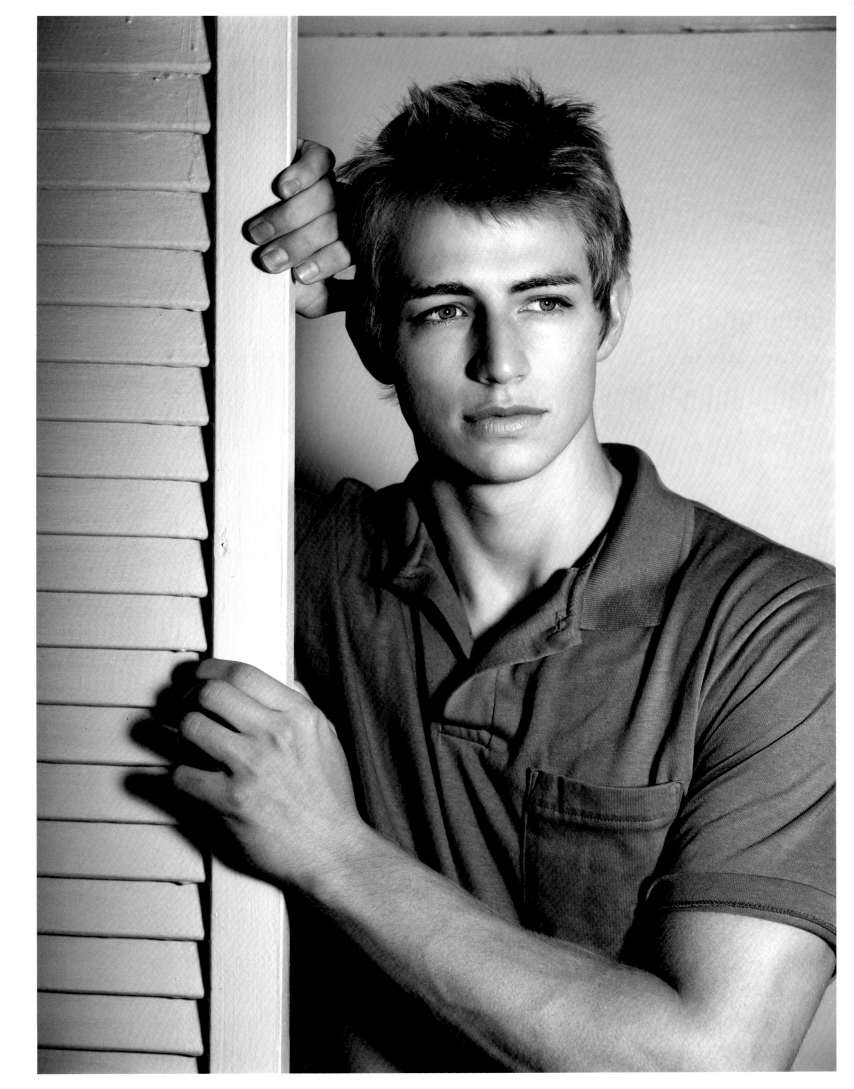

DAYS OF 1909, '10 AND '11

Son of a harrowed, destitute seaman
(from some Aegean island),
he worked in an ironsmith's. His clothes were shabby,
his work shoes split and pitiful,
his hands grimy from the rust and oil.

In the evening, when the place closed,
if there was something he really wanted,
a somewhat expensive tie,
a tie for Sunday-best,
or if in a shop window he'd seen and craved
some nice blue shirt,
he'd sell his body for a shilling or two.

I wonder if in ancient times
renowned Alexandria had any youth more fair,
a more perfect boy than he—who came to nothing:
needless to say, no statue or painting was made of him;
stuck in an ironsmith's dingy shop,
it wasn't long before the arduous work,
and common debauchery, taking its toll, had marred him.

Steven, Lesbos Island, 2000

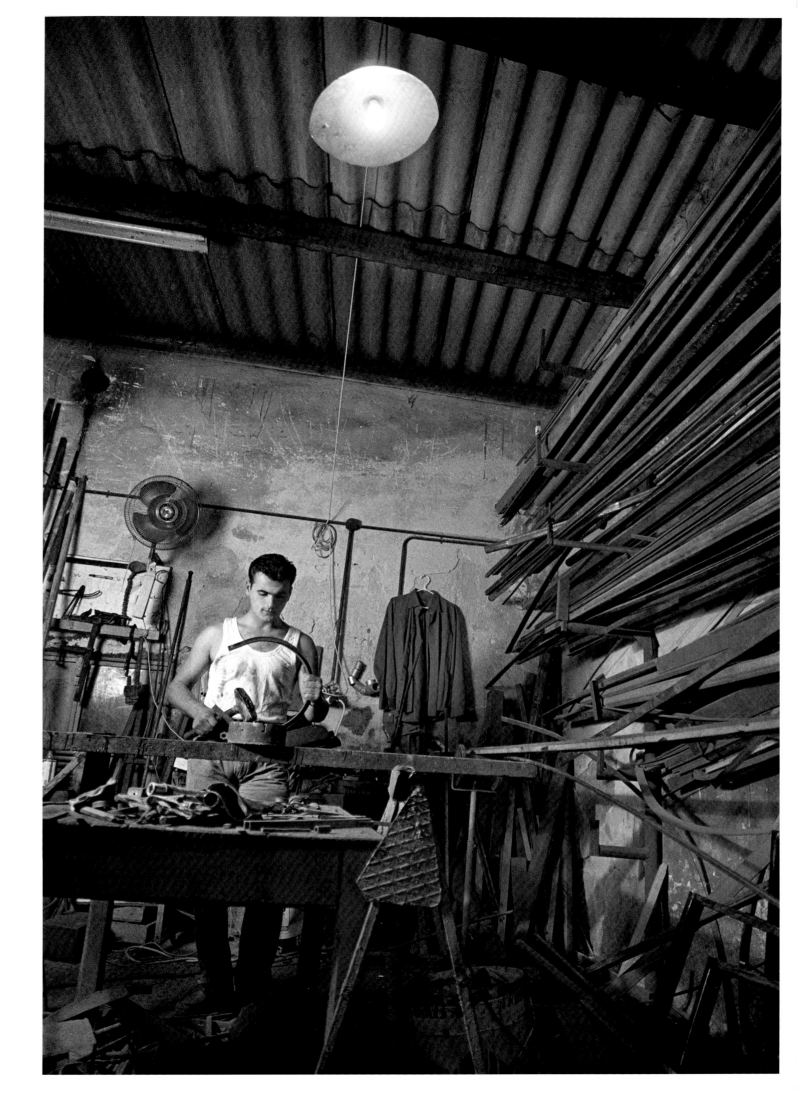

THE BANDAGED SHOULDER

He said he'd bumped into a wall or fallen.
But probably something else was the cause
of the injured and bandaged shoulder.

Because of a rather hasty movement,
in order to take down from a shelf
some photographs he wanted to see more closely,
the bandage had come loose and a little blood had trickled.

I bandaged his shoulder again, and while doing so
I delayed somewhat; for he was in no pain,
and I liked looking at the blood. An object
of my love was what that blood was.

When he'd gone I found beside the chair,
a bloodied rag, from the dressings,
clearly a rag straight for the garbage;
that I put against my lips,
and held there for some time—
the blood of love on my lips.

Elias and Jason, Athens, 2003

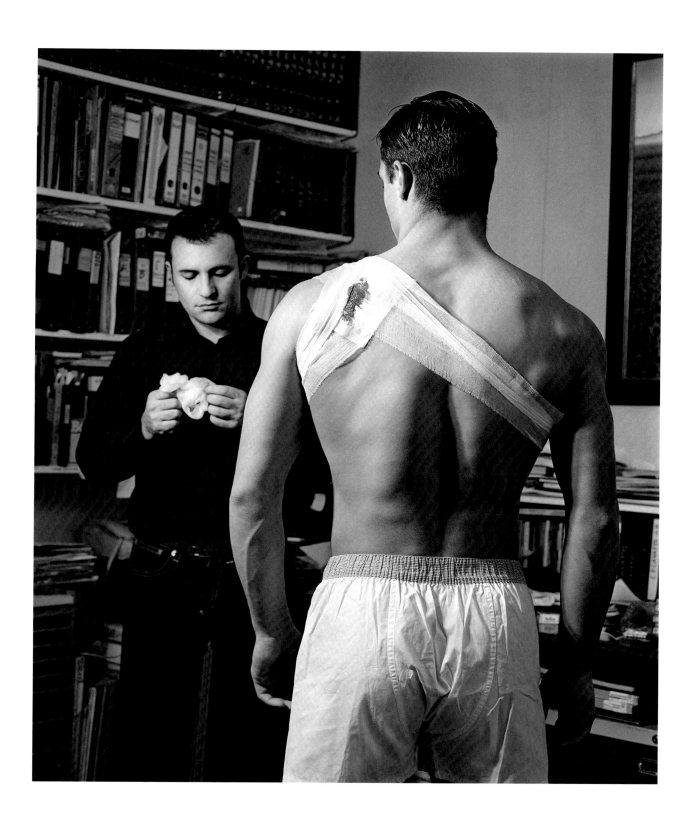

[WITH MY SOUL ON MY LIPS]

It was not at all romantic
when he told me "I might well die".
He said it jokingly. Just as
a lad of twenty-three might say.
And I—twenty-five—took it just as lightly.
Nothing (fortunately) of the pseudo-sentimental verse
that moves elegant (risible) ladies
who sigh at nothing.

And yet when I found myself outside the
door of the house
the idea occurred to me that it was no joke.
He might very well die. And with this fear
I ran up the stairs, it was the third floor.
And without exchanging a word with him,
I kissed him on the brow, the eyes, the lips,
the chest, the hands and on each and every limb;
so that I took heart—as Plato's divine verses
say—so that my soul rose to my lips.

I didn't go to the funeral. I was ill.
Over his white coffin, all alone
his mother wept pure tears for him.

Eduardo and Calen, New York, 2006

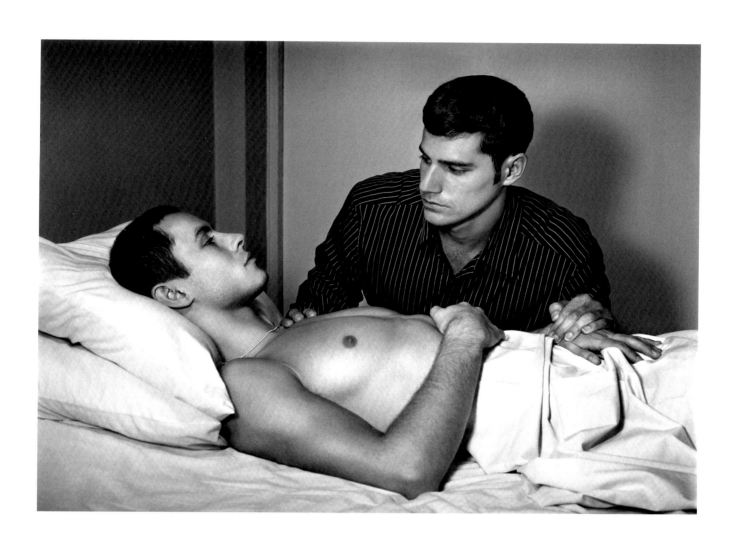

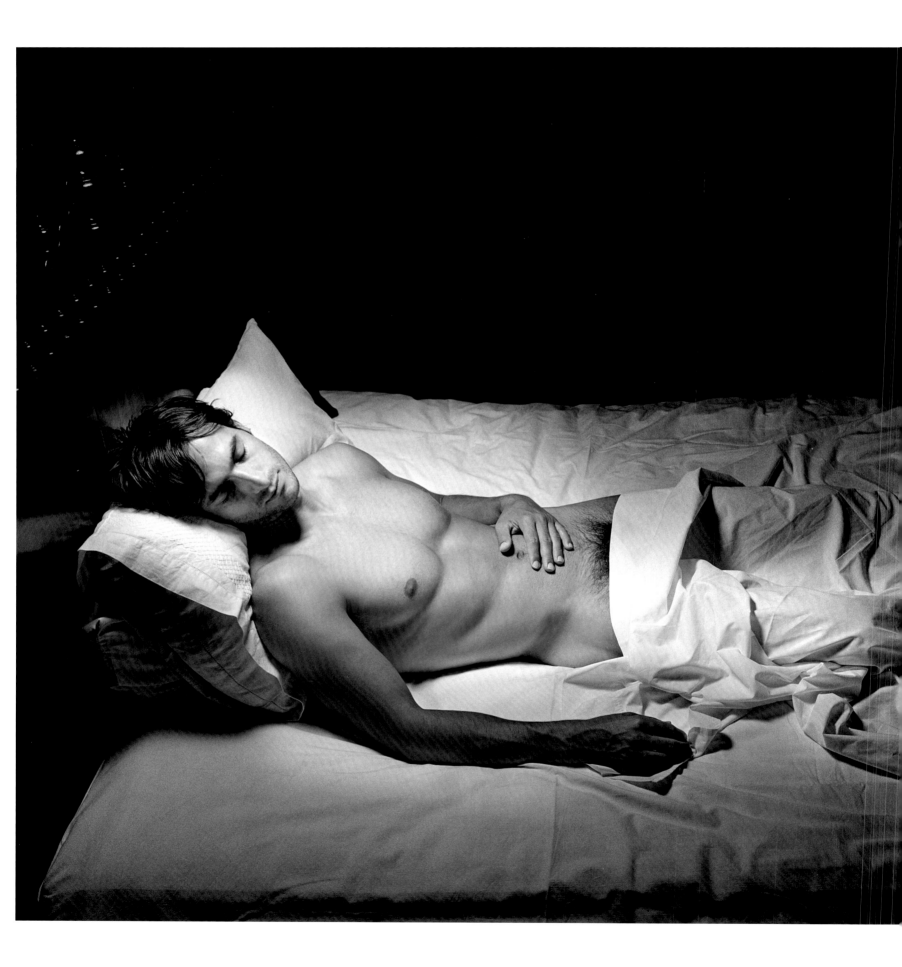

IN A TOWN OF OSROENE

Wounded in a tavern brawl our friend Remon
was brought to us last night around midnight.
Through the window that we left wide open,
the moon lit his handsome body on the bed.
We're a mixture here; Syrians, Greeks, Armenians, Medes.
Such is Remon too. But yesterday when the moon
lit his sensual face,
our thoughts turned to Plato's Charmides.

Seraphim, Lesbos Island, 2005

ADDITION

Whether I am happy or unhappy is not my concern.
Yet one thing I always gladly bring to mind—
that in the huge addition (their addition and one I hate)
that has so many numbers, I am not there
one more of many units. In the total sum
I was not numbered. And this gladness alone suffices.

Quentin Crisp, New York, 1998

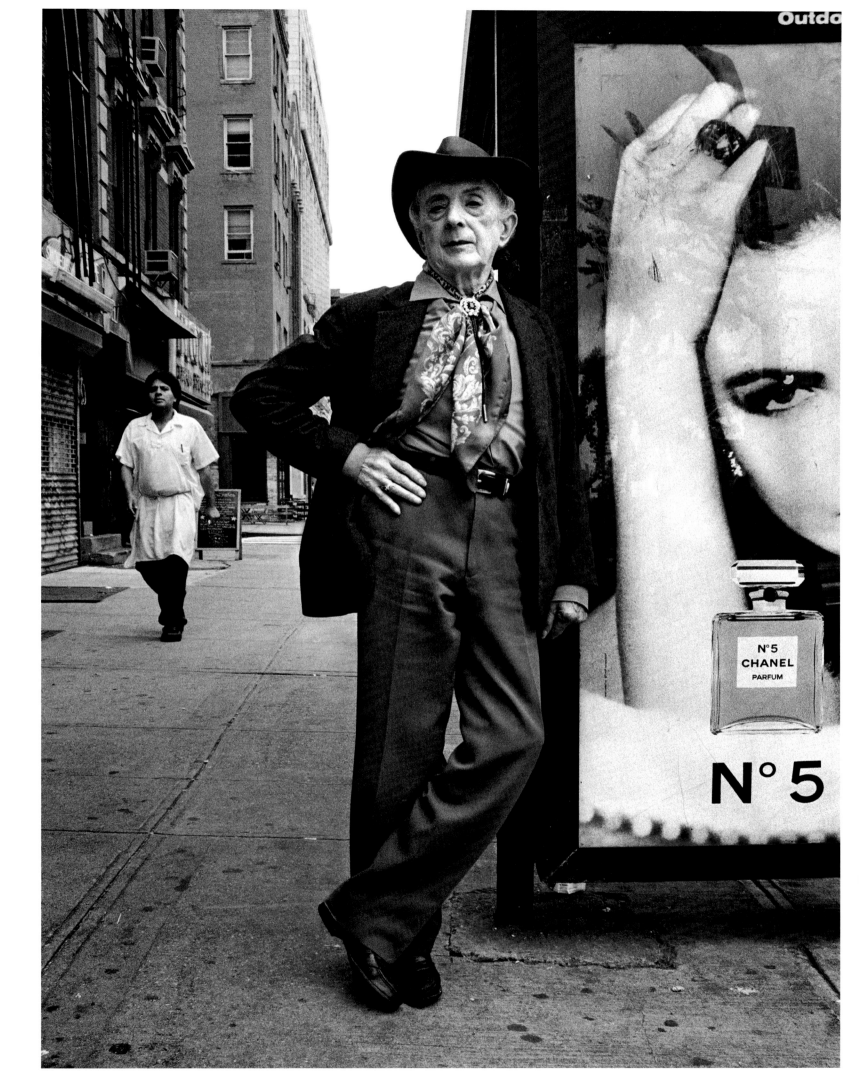

THE FAVOR OF ALEXANDER BALAS

No, I'm not annoyed that one of the chariot's wheels
broke, and that I was deprived of a silly victory.
It's with good wine, and amid lovely roses
that I'll spend the night. Antioch belongs to me.
I'm the most celebrated of all young men.
Adored by Balas, I'm his favorite.
Tomorrow, you'll see, they'll say the contest was unfair.
(And if I were boorish, if I'd secretly ordered it—
the sycophants would rule that even my disabled chariot came first).

Antonio, New York, 2004

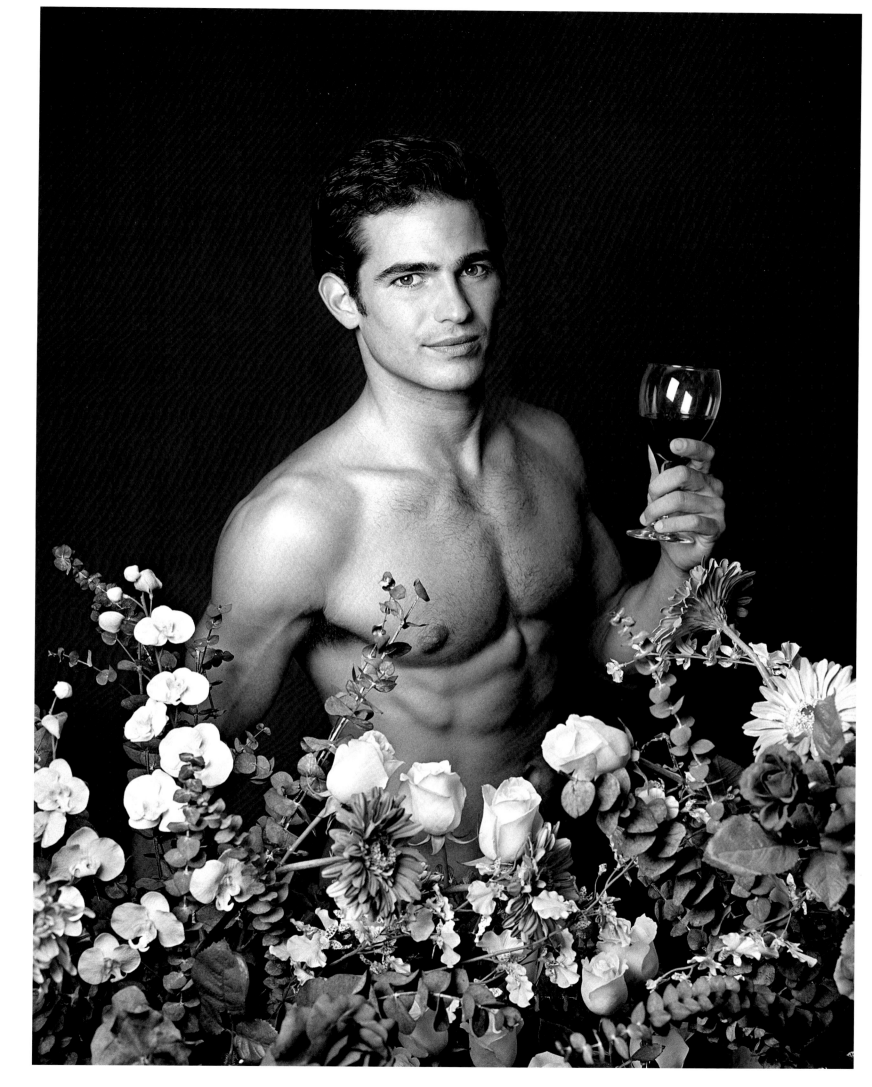

DECEMBER, 1903

And if I cannot talk of my love—
if I do not speak of your hair, your lips, your eyes;
nonetheless your face that I keep in my heart,
the sound of your voice that I keep in my mind,
the September days that dawn in my dreams,
lend shape and color to my words and phrases
whatever subject I turn to, whatever idea I express.

Levi, New York, 2006

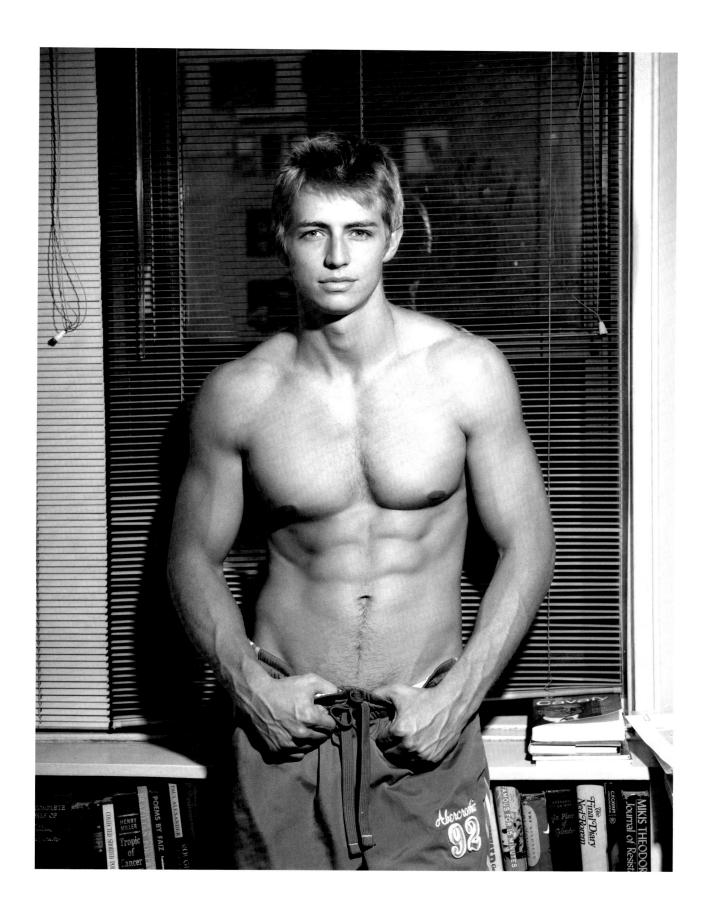

ARISTOBULUS

The palace weeps, the king weeps,
king Herod grieves inconsolably
the whole city weeps for Aristobulus
so tragically and accidentally drowned
while playing in the water with his friends.

And when they learn of it in other parts,
when word gets round up in Syria,
even among the Greeks many will be saddened;
those who are poets and sculptors will mourn,
for Aristobulus was known to them,
and what youth in their imagination
ever matched such beauty as was this boy's;
what statue of a god ever graced Antioch
like to this child of Israel.

The Sovereign Princess wails and weeps;
his mother, the most exalted Jewess.
Alexandra wails and weeps at the tragedy.—
But once she's alone, her grief changes.
She groans, rants, reviles, curses.
How they fooled her! How they tricked her!
How in the end they achieved their goal!
They have brought the Asmonaean house to ruin.
How well that villainous king succeeded;
that treacherous, unscrupulous, wretch.
How well he succeeded. What a fiendish plan
so that even Miriam had guessed nothing.
If Miriam had guessed, had suspected,
she would have found a way to save her brother;
she's queen after all, she could have done something.
How those vile women, Cyprus and Salome
those sluts Cyprus and Salome
would be gloating and rejoicing in secret.—
And for her to be powerless, and obliged
to pretend that she believes their lies;
for her not to be able to go to the people,
to go out and shout to the Jews,
to tell, to tell how the murder was done.

136

Spyros, Lesbos Island, 2000

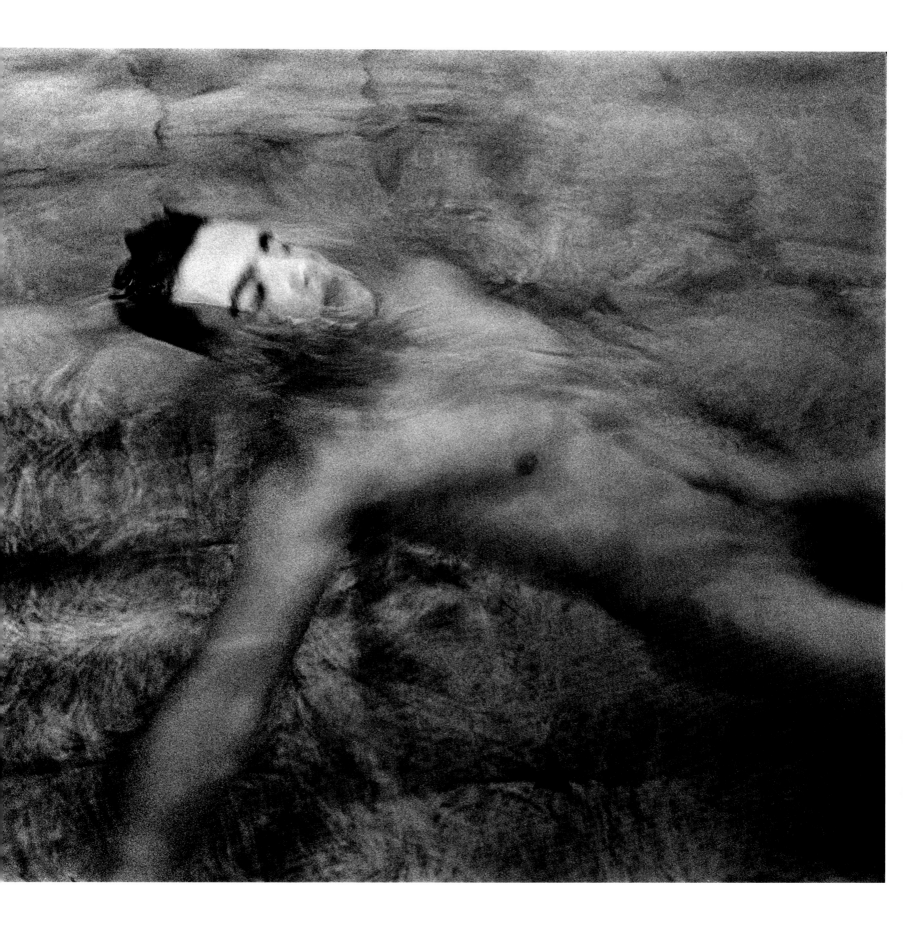

SCULPTOR OF TYANA

As you will have heard, I'm no novice.
A good bit of stone passes through my hands.
And in my hometown of Tyana, I'm known
to all; and here too I've had many statues
commissioned by senators.

 Let me show you
some without more ado. Observe this Rhea;
august, full of forbearance, age-old.
Observe Pompey. Marius,
Aemilius Paulus, Scipio Africanus.
To the best of my ability, faithful likenesses.
Patroclus (I've still a few touches to add).
Next to those blocks of yellowy marble
over there, that's Caesarion.

And for some time now I've been busy
working on a Poseidon. I've given much thought
to his steeds in particular, how I might fashion them.
They have to be sufficiently light that
their bodies and legs might clearly show them
not treading on the ground, but racing over the waters.

Yet this is by far my favorite work
which I wrought with emotion and utmost care;
this one, on a warm day in summer
when my mind soared toward the ideal,
this one here, I dreamt of this young Hermes.

Arman, New York, 2001

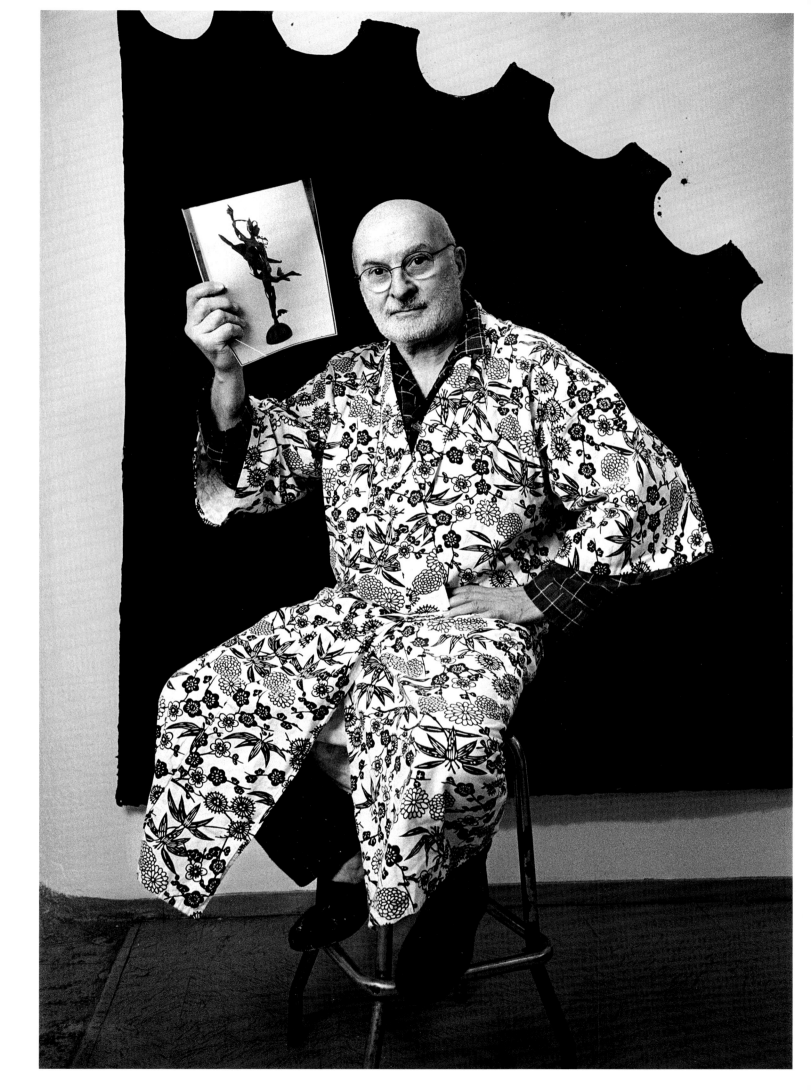

IONIC

For we smashed their statues,
for we drove them from their temples,
even so the gods are by no means dead.
O land of Ionia, it's you they cherish still,
it's you their souls remember still.
When an August morn dawns upon you
your air is filled by vigor from their lives;
and at times an ethereal adolescent figure,
indistinct, with swift stride,
crosses your hills.

Juan, Mexico City, 2004

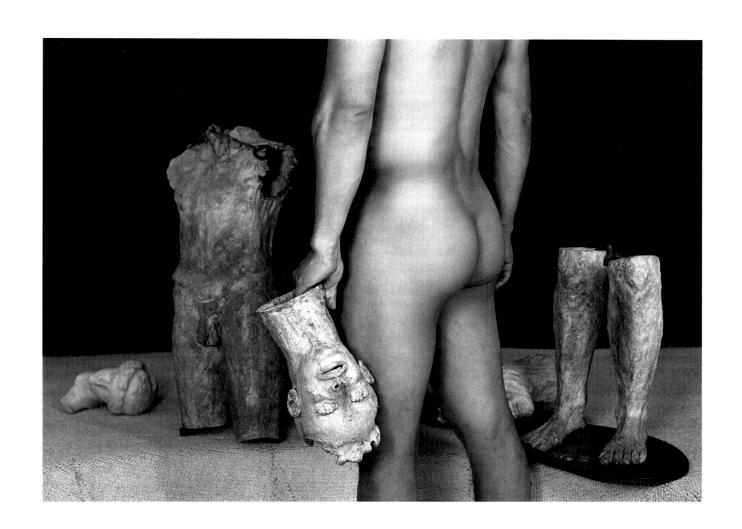

MONOTONY

Each monotonous day is followed
by another identical one. The same things
will happen, and will happen again—
these like moments find us and leave us.

One month passes and brings another month.
What's to come is easy to surmise;
it's those dreary things of yesterday.
And tomorrow ends up not seeming like tomorrow.

Naguib Mahfouz, Cairo, 2000

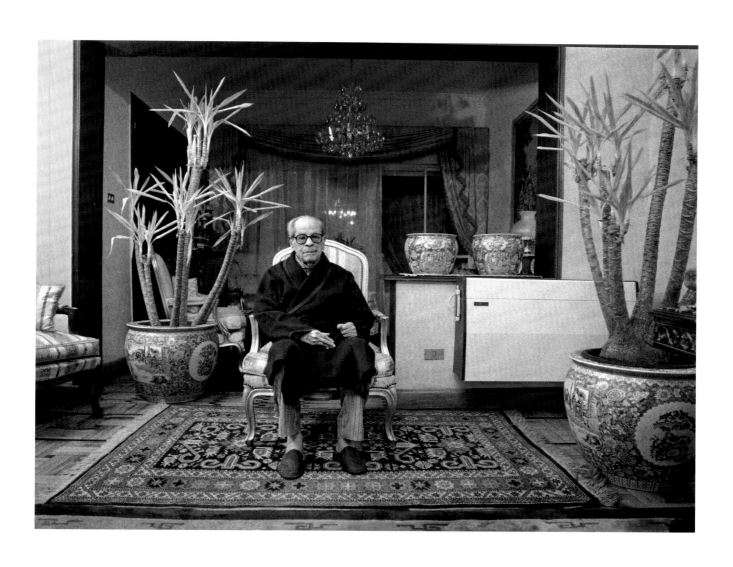

JANUARY, 1904

Oh these January nights,
when I sit and in my mind recreate
those moments and encounter you,
and hear our last words and also hear our first.

These despondent January nights,
when the vision goes and I'm left alone.
How quickly it goes and dissolves—
the trees, streets, houses, lights all go;
your sensual image fades and disappears.

Leo and Bill, Lesbos Island, 2003

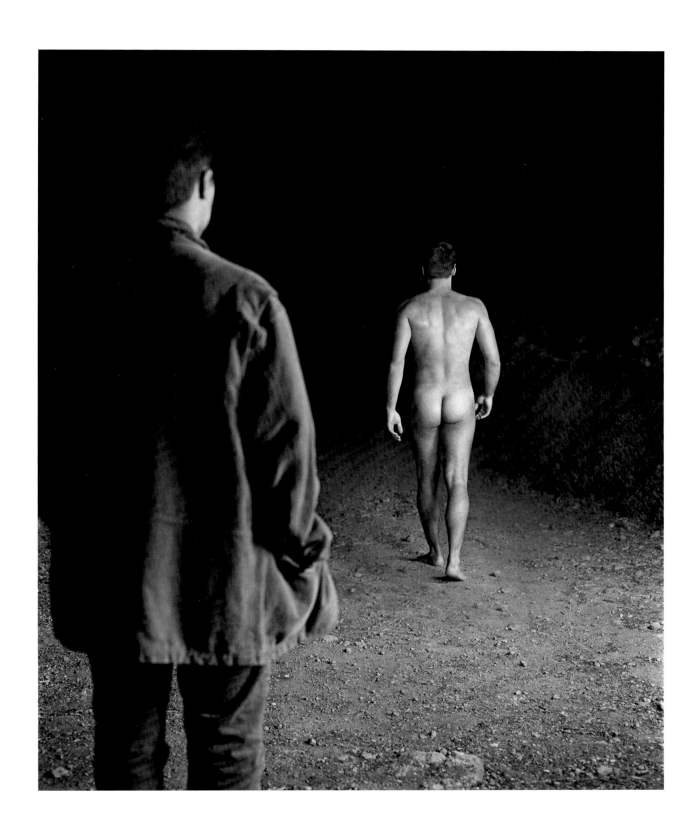

ALL OVER

Amid fear and suspicions,
with troubled mind and terrified eyes,
we languish and plan what to do
to avoid the certain
danger so horribly threatening us.
But we're wrong, it's not this that lies ahead;
the signs were false
(either we failed to heed them or interpret them correctly).
Some other disaster, one we never imagined,
suddenly and swiftly befalls us,
and unprepared—no time now—we're swept away.

Chuck Close, New York, 2002

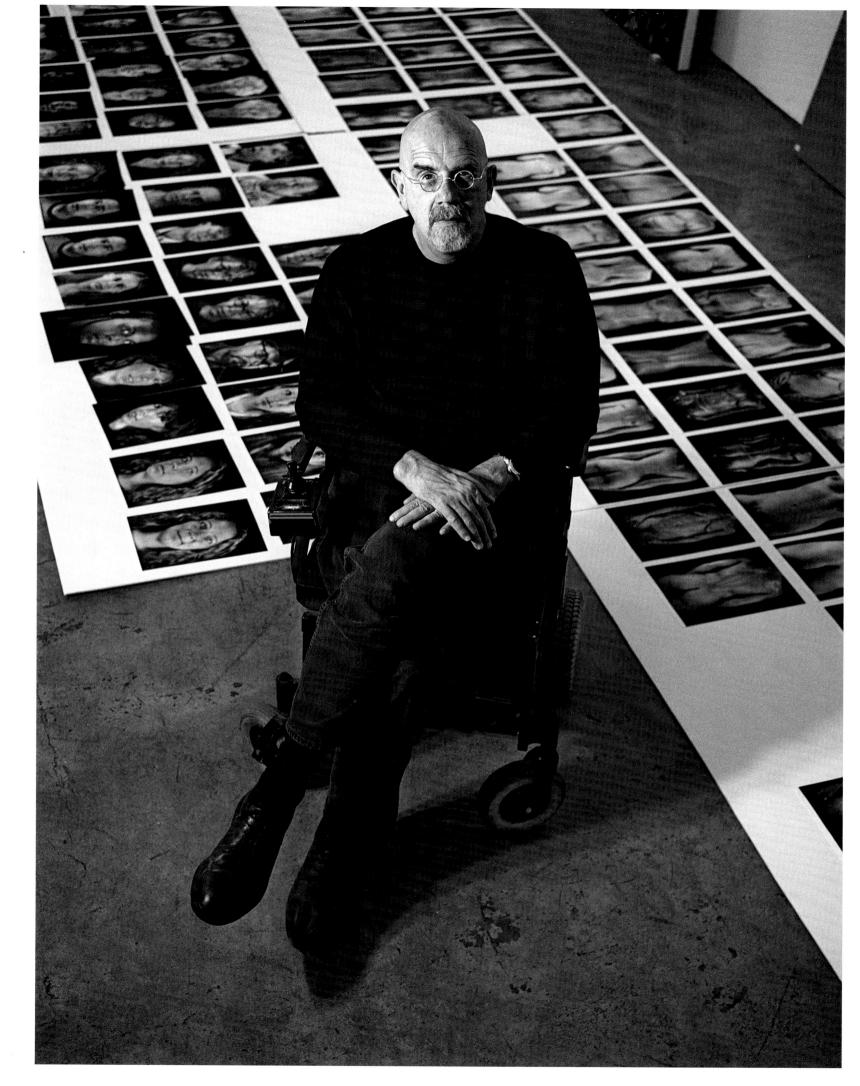

WALLS

Without consideration, without pity, without shame
they built great towering walls all around me.

And I sit here now despairing.
I think of nothing else: this fate gnaws at my mind;

for I had so many things to do outside.
Why didn't I notice when they were building the walls.

But I never heard any noise or sound of builders.
Imperceptibly they cut me off from the outside world.

John, Lesbos Island, 2002

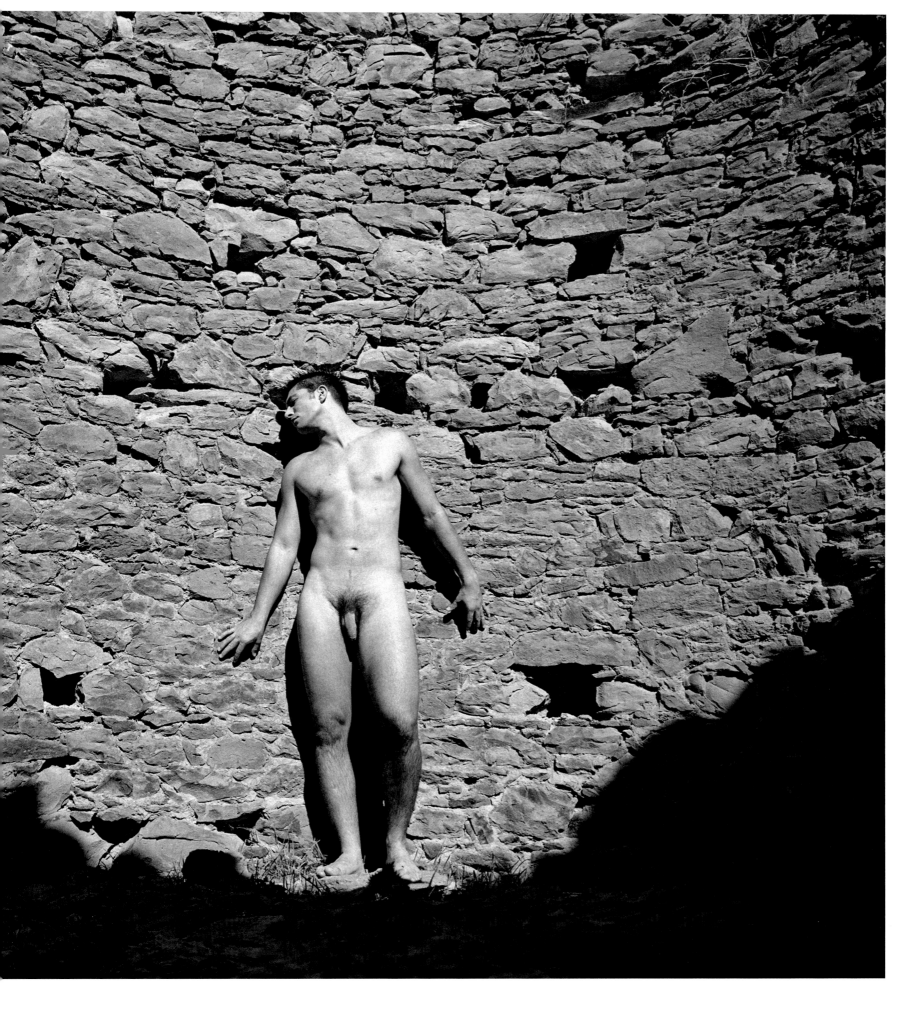

CHE FECE . . . IL GRAN RIFIUTO

For some people there comes a day
when they are obliged to say either Yes
or No. It is immediately clear who has
the Yes ready within, and saying it goes

far beyond to honor and conviction.
Refusing, the other has no regrets. If asked again,
he would still say no. And yet he is beset
by that no—the right one—throughout his life.

Gore Vidal, Los Angeles, 2005

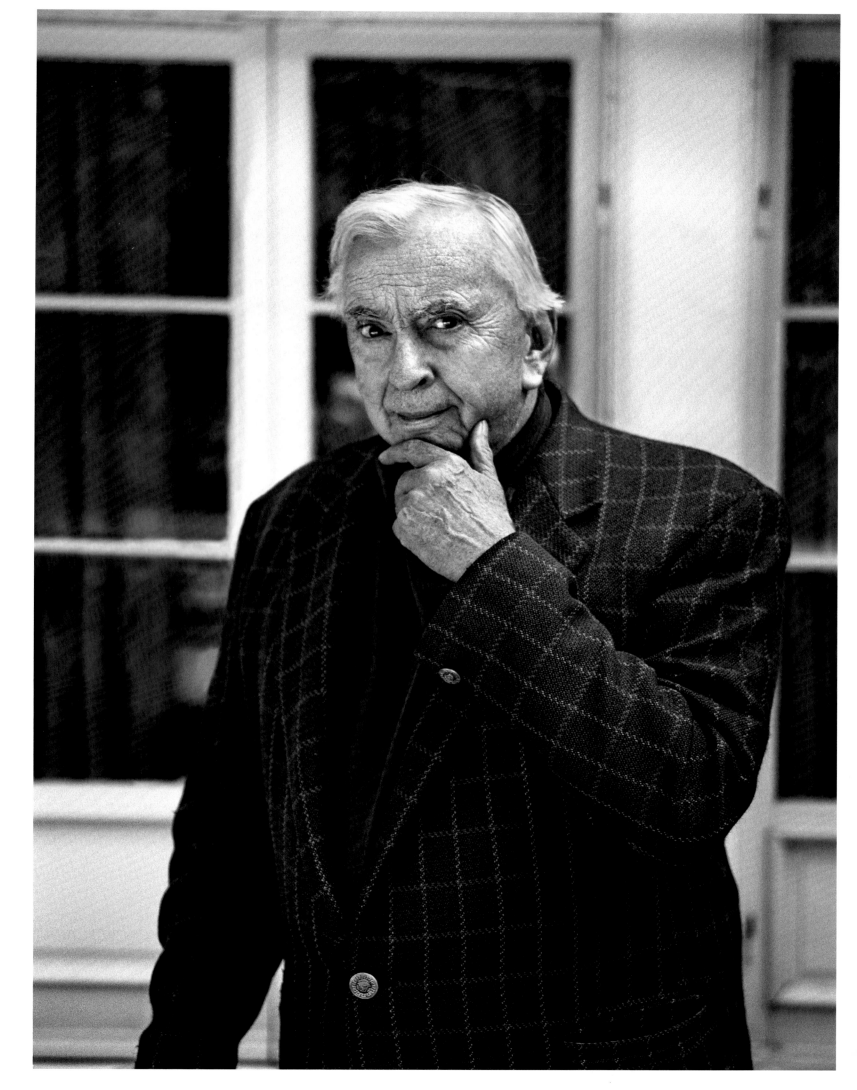

NOTHING CONCERNING LACEDAEMONIANS

Love sincerity of course
and serve it.
Yet modestly, knowing that most probably
you will reach the point where sincerity doesn't do.
It is good; but feeling is splendid too.
Honestly and sincerely you will express yourself
on numerous matters and will be of benefit.
Others will respect you and rightly so:

<div align="right">what a sincere man!</div>

But come down a peg; don't flatter yourself
for (as you well know) "Nothing concerning

<div align="right">Lacedaemonians".</div>

Jean Baudrillard, Paris, 1999

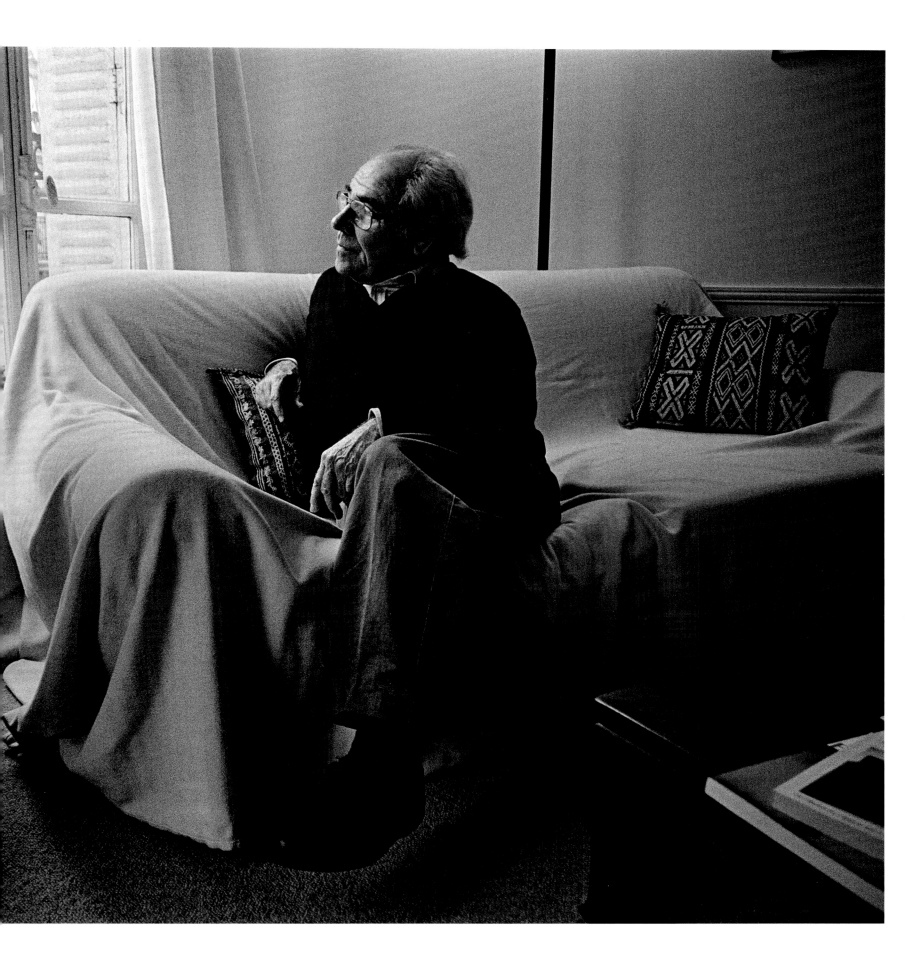

THERMOPYLAE

Honor to those who in their lives
resolved to defend some Thermopylae.
Never wavering from duty;
just and forthright in all their deeds,
but with pity and compassion too;
generous whenever rich, and when
poor, still generous in smaller ways,
still helping all they can;
always speaking the truth,
yet without hatred for those who lie.

And still more honor is their due
when they foresee (and many do foresee)
that Ephialtes will eventually appear,
and the Medes will, in the end, get through.

Thermopylae, 2003

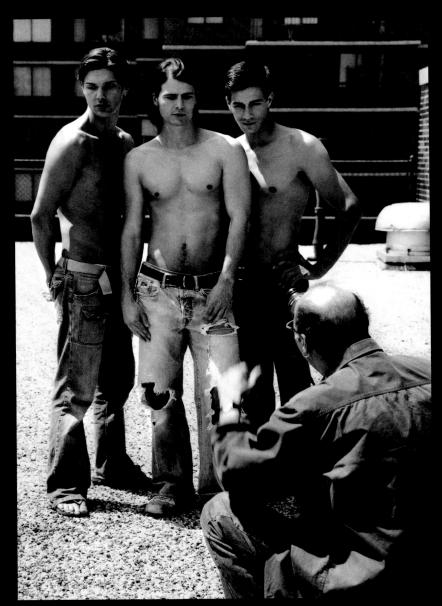

Rodrigo, Jeremy and Dante, New York, 2006

ONE DAY A PUBLISHER asked me to illustrate for him a collector's edition of five poems by Cavafy, the greatest Greek poet since antiquity. As I had always been fond of his poetry, I gladly consented and started to think of the images evoked by Cavafy's lines. Besides, years before I had noticed that in some of the photographs I had taken of Greek youths there were subconscious references to his poems.

At first I thought I would not have any difficulty with his erotic poems—only to be proven wrong as I will explain later. But what was I to do with his other poems, such as "Voices," "Monotony," or "Ithaca?" Then, as I was reading the poem "Sculptor of Tyana," I remembered that my friend Arman had made a sculpture of the god Hermes, just like Cavafy's sculptor of Tyana. I had my answer: who else could have better illustrated this poem than a famous modern sculptor who happened to have been inspired by Hermes as well?

After that, I started to search in my mind for friends and acquaintances whose life or work was somehow connected with Cavafy and his world, and I tried to visualize them through his poetry.

I thought that the best models for this work would be people from the world of letters and the arts, people who knew and admired Cavafy's poetry.

Thus, for the poem "Voices" I chose the poet Richard Howard, who has completely covered the walls of his bathroom with photographs of dead personalities. Howard, whose life has much in common with Cavafy's, had even published a collection of poems about his dead friends at that time.

The next person I thought of was the excellent photographer Duane Michals, another admirer of Cavafy's work, who like me has drawn inspiration for some of his photographs from poems by Cavafy. I had Duane sit drinking his coffee at New York's renowned Factory Café (pretty similar to the cafés that I believe Cavafy would have frequented) and wondering about the presence of a young man at "The Next Table." I made sure that the young man looked like the models that Duane likes and I illustrated this poem like a photo-sequence, typical of his style.

It was Gabriel García Márquez—a man with a life rich in adventures and experiences—that I put on the road to "Ithaca": I photographed him as he walked holding his manuscripts and his umbrella.

I asked Michel Tournier, who lives in an old presbytery, to pose for "Candles." I thought I might photograph the erotically imaginative Pierre and Giles for the poem "Chandelier," and I was pleasantly surprised to find a huge chandelier in their sitting room.

It was in the same spirit that I approached the rest of my photographic sessions.

During those sessions with artists and authors I did not face many difficulties. They were all familiar with Cavafy and I have even videoed some of them reciting, in their own unique manner, the poem for which they posed.

What turned out to be unexpectedly more difficult was the photographing of the young men that I used as models for the erotic poems. None of them were familiar with Cavafy and most did not even care to read the poem they posed for so that they could be true to their role. But then, that was why they had been chosen: to play themselves—the unsuspecting (and sometimes vulgar) beautiful lower-class youths that the poet admired and had described in his poems in his unique charming, sensitive, and sensual way.

In the end, I had collected sixty-four photographs—enough to put this book together—while the collector's edition was forgotten and never materialized.

The illustration of the poems took me many years—from 1999 until now—and, unfortunately, some of the people I photographed are no longer among us.

All of the photographs were taken on film, apart from two or three that were taken with a digital camera.

In Cavafy's poems the images are crisp and clear. There are no excessive words, no frills. I tried to make my photographs true to that spirit.

The selection of the poems was based on the images they evoked and the models available for those images. For this reason, I did not choose only from among the published poems and those authorized by Cavafy himself, but also from the uncollected and unpublished. Some of them, although not very good poems, were included because their lines provided the inspiration for a photograph.

It is not easy to photograph people whose work and commitments often make them inaccessible. Even when they are friends, it may take time before a meeting is arranged.

Some of the unexpected things that happened at our meetings may seem amusing in retrospect but were quite disturbing back then, as when I found myself at Gore Vidal's doorstep after a six-hour flight from New York to Los Angeles. Lugging my heavy and sensitive equipment, I rang the unmarked bell for half an hour. I was about to give up half thinking that I had come to the wrong address when, to my indescribable relief, the aging writer opened the door himself apologizing that his valet was out and he had fallen into a deep slumber.

It was also in Los Angeles that Clive Barker would not consent to being photographed unless the rather provocative painting he had made for his husband became a distinct part of my photograph.

In New York, William Weslow would interrupt the shooting every few minutes and, while still naked but furiously waving his arms, chase away the pigeons that soiled his veranda.

Gilles seemed to be in bad spirits on the day of the shooting and would not embrace Pierre because he claimed that their relationship was over, while, as a final example, Jeff Koons had forgotten to shave, which was reason enough for him to put the shooting off till the next day. Then, it lasted for only fifteen minutes because in the meantime he had become upset by a

telephone call from Cicciolina's lawyer. All the same, when he later saw the photographs, he was quite enthusiastic and told me they were the best anyone had taken of him.

I obviously derived immense pleasure from meeting people I love and admire and having them willingly pose for me either as Cavafy himself or as part of some other image inspired by his poems. Now that the work has been completed and in spite of the excitement it gives me to see it collected between the covers of this book, I also feel a little sad at the end of this beautiful journey with such charming and distinguished fellow travelers.

I do not know whether Cavafy himself would have approved of these photographs. However, when I think of how boldly he turned his urges and passions into poetry and made them public at a time when Oscar Wilde's imprisonment in England was still fresh in the mind, I fear he would probably consider my photographs quite modest.

DIMITRIS YEROS

Edward Albee (born in 1928) is one of the greatest living American dramatists, best known for his works *Who's Afraid of Virginia Woolf?*, *The Zoo Story*, *The Sandbox*, and *The American Dream*. His plays have been performed on stages around the globe. He has received many awards, including three Pulitzer Prizes for drama and a Special Tony Award for Lifetime Achievement (2005).

Arman (1928–2005) was a French-born American painter who moved from using objects as paintbrushes ("*allures d'objet*") to using them as the painting itself. He is best known for his "accumulations" of found objects and the destruction/recomposition of objects. Many exhibitions of his works have been presented in galleries and museums.

David Armstrong (born in 1954) is an American photographer and the husband of Clive Barker.

Clive Barker (born in 1952) is an English author, film director, and visual artist, best known for his work in metaphysical fantasy and horror fiction. Barker's distinctive style is characterized by the notion of hidden fantastical worlds within our own, and the construction of coherent, complex, and detailed universes. His books such as *The Hellbound Heart* or *Abarat*, and films such as *Hellraiser* have earned him an international following.

Jean Baudrillard (1929–2007), one of the most important and influential French thinkers of our times, was a cultural theorist, sociologist, philosopher, political commentator, and photographer. His work is frequently associated with postmodernism and post-structuralism.

Antonio Carmena was born and raised in Madrid, Spain. He is a soloist of the New York City Ballet and the recipient of numerous awards.

Chuck Close (born in 1940) is an American painter and photographer who achieved fame as a photorealist through his massive-scale portraits. Though a catastrophic spinal artery collapse in 1988 left him severely paralyzed, he has continued to paint and produce work which remains sought after by museums and collectors.

Quentin Crisp (1908–1999) was an English writer. He became a gay icon in the 1970s after the publication of his memoir, *The Naked Civil Servant*. A dramatization of his memoir, starring John Hurt, was shown on American television in 1975. He first presented his one-man show on stage in 1978 to very favorable reviews.

Leonidas Depian (Athens 1927–2008) was a distinguished Greek dancer and choreographer. He had a long career as the principal dancer of the Grand Ballet du Marquis de Cuevas, Le Ballet de France, the American Ballet Theater, and appeared in all the important theaters of the world.

Mark Doty (born in Tennessee in 1953) is an American poet and memoirist. He has written twelve books of poetry and three memoirs. In 2008 he won the National Book Award, and in 1995 was the first American poet to win the T.S. Eliot Prize for Poetry.

Olympia Dukakis (born in 1931) is an American actress, born in Lowell, Massachusetts, of Greek immigrants. She has been starring in films since 1964, and won an Oscar for Best Supporting Actress in the film *Moonstruck* (1987). Dukakis has been married to actor Louis Zorich since 1962. They have three children.

Charles Henri Ford (1913–2002) was an American novelist, poet, filmmaker, photographer, and collage artist best known for his editorship of the Surrealist magazine *View* (1940–1947) in New York City, and as the partner of the artist Pavel Tchelitchew.

Carlos Fuentes (born in 1928) is a Mexican writer and one of the best-known living novelists and essayists in the Spanish-speaking world. Fuentes has influenced contemporary Latin American literature, and his works have been widely translated into English and other languages.

Richard Howard (born in 1929) is a distinguished American poet, literary critic, essayist, teacher, and translator. He has won the Pulitzer Prize for poetry, and for his translations the PEN Translation Prize and the American Book Award. He served as Poet Laureate of the State of New York from 1994 to 1997.

Jeff Koons (born in 1955) is an American artist whose work incorporates kitsch imagery using painting, sculpture, and other forms, often in large scale. Koons's work has been exhibited internationally and is in numerous public collections.

David Leddick is a leading expert in male nude photography. He is the author of several award-winning anthologies on the subject. He has also written novels and biographical studies of George Platt Lynes, Paul Cadmus, and Lincoln Kirstein. His latest book is the acclaimed *In the Spirit of Miami Beach* from Assouline Press.

Edward Lucie-Smith (born in 1933) is a British writer, poet, art critic, curator, broadcaster, and author of exhibition catalogues. He is well known for his numerous books on art and has lectured extensively all over the world.

Naguib Mahfouz (1911–2006) was an Egyptian novelist and the first Arab writer to win the Nobel Prize for Literature (in 1988). He is regarded as one of the first contemporary writers of Arabic literature.

Vladimir Malakhov (born in 1968) was a Principal Dancer with the American Ballet Theatre, the Vienna State Opera Ballet, the National Ballet of Canada, the Metropolitan Opera House in New York, and others, and has danced on the most prestigious stages of the world. He is currently the artistic director and first soloist of the Berlin State Ballet.

Gabriel García Márquez (born in 1927) is a Colombian novelist, considered one of the most significant authors of the twentieth century and a master of magical realism, a style that weaves together realism and fantasy. In 1982 he was awarded the Nobel Prize in Literature. He has written many acclaimed non-fiction works and short stories, but is best known for his novels, such as *One Hundred Years of Solitude* (1967) and *Love in the Time of Cholera* (1985).

Duane Michals (born in 1932) is an American photographer. Michals's style often features photo-sequences and the incorporation of text to examine emotion and philosophy, resulting in a unique body of work. He has exhibited his work all over the world and published numerous books. In 1970 his works were shown at the Museum of Modern Art in New York City.

Pierre et Gilles (Pierre Commoy and Gilles Blanchard) are French artistic and romantic partners. They produce highly stylized photographs, building their own sets and costumes as well as retouching the photographs. Many exhibitions of their work have been organized around the world.

Timo Schnellinger is an American actor. He has appeared on the stage in New York and London and has also taken part in films.

Michel Tournier (born in 1924) is a French writer. His works are highly-regarded and have won important awards such as the *Grand Prix du roman de l'Académie française* in 1967 for *Vendredi ou les limbes du Pacifique,* and the Prix Goncourt for *Le Roi des aulnes* in 1970.

Gore Vidal (born in 1925) is a significant internationally known American novelist, screenwriter, playwright, essayist, short story writer and politician. Early in his career he wrote the ground-breaking *The City and the Pillar* (1948) which outraged mainstream critics as one of the first major American novels to feature unambiguous homosexuality. His essays are critical of hypocrisy in contemporary American politics and culture.

William Weslow (born in 1925) is an American dancer. He spent most of his career, as soloist, with the New York City Ballet, and the American Ballet Theater. On Broadway, Weslow was featured in *Annie Get Your Gun* and appeared in the original casts of four other musicals, including *Call Me Madam*, *Wonderful Town*, and *Plain and Fancy*. He also performed at Radio City Music Hall.

Tom Wesselman (1931–2004) was one of the most important American pop artists. He specialized in found art collages. He is distinguished by his relatively flat motifs painted in a simplified form, using only outlines. His works are displayed in many galleries and museums.

Edmund White (born in 1940) is an American author and literary critic. White's best-known books are *A Boy's Own Story*, *The Beautiful Room Is Empty* and *The Farewell Symphony*.

He has received many awards and distinctions: he is a Member of the American Academy of Arts and Letters, an Officier de L'Ordre des Arts et des Lettres, and a Member of the American Academy of Arts and Sciences.

John Wood is an award-winning poet and photography critic who has written and edited over thirty books. In 2005, he co-curated the Smithsonian Institution/National Museum of American Art exhibition "Secrets of the Dark Chamber: The Art of the American Daguerreotype." His latest book of poetry, *Endurance and Suffering*, won the 2009 Deutscher Fotobuchpreis Gold Medal.

Mark Wunderlich (born in 1968) has published individual poems, essays, reviews, and interviews in the *Paris Review, Yale Review, Boston Review, Chicago Review, Fence,* and elsewhere. He won the Lambda Literary Award for his book *The Anchorage*.

Dimitris Yeros (born in 1948) is a painter and photographer who has had fifty-four individual exhibitions of his work held in his native Greece and abroad in locations as diverse as Berlin, Milan, and New York. He has also participated in numerous international group exhibitions, biennials and triennials around the world. Past publications of his photographs include *Theory of the Nude, Periorasis*, and a self-titled book of his paintings. Works by Dimitris Yeros can be found in private collections, national galleries, and museums around the world.

INDEX OF PROPER NAMES

ARTISTS AND AUTHORS

Edward **Albee**, 27

Arman, 139

David **Armstrong**, 93

Clive **Barker**, 93

Jean **Baudrillard**, 153

Antonio **Carmeña**, 81

Chuck **Close**, 147

Quentin **Crisp**, 131

Leonidas **Depian**, 29

Mark **Doty**, 37

Olympia **Dukakis**, 119

Charles Henri **Ford**, 38-39

Carlos **Fuentes**, 105

Richard **Howard**, 35

Jeff **Koons**, 65

David **Leddick**, 63

Edward **Lucie-Smith**, 109

Naguib **Mahfouz**, 143

Vladimir **Malakhov**, 29

Gabriel García **Márquez**, 25

Duane **Michals**, 83

Pierre and **Gilles**, 75

Timo **Schnellinger**, 78-79

Michel **Tournier**, 55

Gore **Vidal**, 151

William **Weslow**, 49

Tom **Wesselmann**, 71

Edmund **White**, 51

John **Wood**, 59

Mark **Wunderlich**, 45

Dimitris **Yeros**, 87

MODELS

Adam, 10, 69
Alexey, 16
Andrew, 77
Angelo, 67, 89
Antonio, 133
Bill, 145
Brad, 117
Calen, 127
Charles, 113
Christopher, 97
Christos, 4
Costas, 57, 87
Dante, 41, 156
Daron, 63
Dionisios, 103
Diego Centeño, 33, 107, 111
Douglas, 83
Eduardo, 127
Elias, 125
Eric, 73
Felipe, 2-3, 53
François, 107
Garret, 117
Issa, 101
J., 42-43
Jason, 47, 125
Jeremy, 156
John, 115, 149
Juan, 141
Leo, 145
Leonardo, 85
Levi, 121, 135
Mad, 89
Michael, 63
Nicos, 109
P., 42-43
Photis, 109
Rodolfo, 85
Rodrigo, 41, 156
Sakis, 31
Sean, 117
Seraphim, 95, 128-129
Spyros, 136-137
Steven, 123
Teo, 99
Tom, 73
Zacharias, 23
Zachary, 91

INDEX TO THE POEMS

Addition, 130
All Over, 146
And I Sat and Reclined on Their Beds, 108
Aristobulus, 136
Artificial Flowers, 70
Before Time Changes Them, 112
Birth of a Poem, 52
Caesarion, 96
Candles, 54
Chandelier, 74
Che Fece . . . Il Grand Rifiuto, 150
Craftsman Of Craters, 30
Days of 1896, 90
Days of 1901, 66
Days of 1903, 76
Days of 1908, 78
Days of 1909, '10 and '11, 122
December, 1903, 134
Far Back, 40
Grey, 118
He Asked About the Quality, 72
He Came to Read—, 98
House with Garden, 64
I Brought To Art, 26
I Went, 92
In a Town of Osroene, 129
In an Old Book—, 50
In Despair, 106
In the Boring Village, 56
In the Same Place, 104
In the Street, 102
Ionic, 140
Ithaca, 24
I've Looked so Much—, 116

January, 1904, 144
Lovely Flowers and White as Well Befitted, 68
Monotony, 142
Morning Sea, 22
Nothing Concerning Lacedaemonians, 152
On Hearing of Love, 94
On the Stairs, 86
One Night, 42
Passing Through, 46
Portrait of a Twenty-Three-Year-Old Painted by
 His Friend of Similar Age, an Amateur, 110
Remember, Body . . . , 48
Return, 58
Sculptor of Tyana, 138
September 1903, 32
Since Nine O'Clock—, 28
Sophist Leaving Syria, 114
So They May Come—, 39
Supplication, 118
That's What, 36
The Bandaged Shoulder, 124
The Café Entrance, 80
The Favor of Alexander Balas, 132
The Mirror in the Entrance, 100
The Next Table, 82
The Souls of Old Men, 60
Theatre of Sidon (A.D. 400), 44
Their Beginning, 88
Thermopylae, 154
To Remain, 84
To Sensual Pleasure, 62
Voices, 34
Walls, 148
[With my Soul on My Lips], 126

Book Design: Dimitris Vecchios
Photo Editors: Natassa Markidou, Dimitris Yeros
Non-Poetic Translation: Nick Lingris
Negative Scans: Yorgos Marinos
Color Separation: Graphicon

Dimitris Yeros is represented by the following galleries:

Throckmorton Fine Arts, New York
www.throckmorton-nyc.com

Vance Martin, San Francisco
www.vancemartin.com

Callicoon Fine Arts, Callicoon, New York
www.callicoonfinearts.com

Radiant Light Gallery, Portland
www.radiantlightgallery.com

Holden Luntz Gallery, Palm Beach
www.holdenluntz.com

For more information please visit

www.yeros.com

INSIGHT EDITIONS
Publisher: Raoul Goff
Designer: Barbara Genetin
Editorial Director: Jake Gerli
Editor: Lucy Kee
Production Manager: Anna Wan

INSIGHT EDITIONS
3160 Kerner Blvd., Unit 108
San Rafael, CA 94901
www.insighteditions.com

Library of Congress Cataloging-in-Publication Data available.

ISBN: 978-1-608870-13-4

10 9 8 7 6 5 4 3 2 1

ROOTS of PEACE REPLANTED PAPER
Insight Editions, in association with Roots of Peace, will plant two trees for each
tree used in the manufacturing of this book. Roots of Peace is an internationally
renowned humanitarian organization dedicated to eradicating land mines world-
wide and converting war-torn lands into productive farms and wildlife habitats.
Together, we will plant two million fruit and nut trees in Afghanistan and provide
farmers there with the skills and support necessary for sustainable land use.

Manufactured in Singapore by Insight Editions.